IMAGES
*of America*

# NATCHEZ
LANDMARKS, LIFESTYLES, AND LEISURE

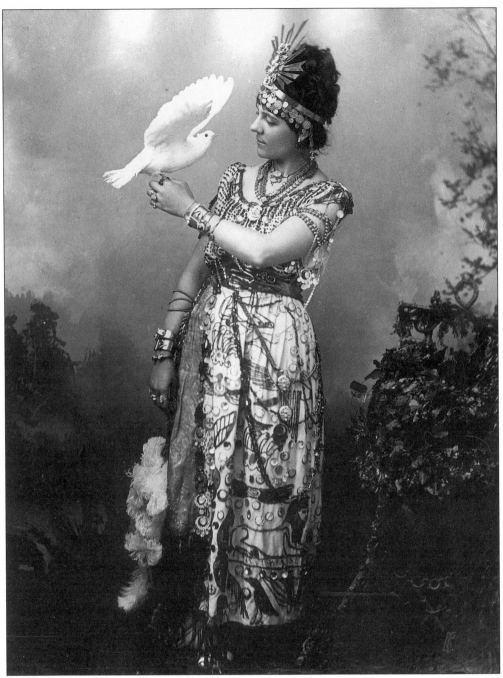

Mary Britton as Queen of the Kirmess in 1887 epitomizes the social scene in Natchez in the late 19th century, when revelry reigned.

IMAGES
*of America*

# NATCHEZ
## LANDMARKS, LIFESTYLES, AND LEISURE

Joan W. Gandy
and Thomas H. Gandy

ARCADIA

Copyright © 1999 by Joan W. Gandy and Thomas H. Gandy.
ISBN 0-7385-0324-X

Published by Arcadia Publishing,
an imprint of Tempus Publishing, Inc.
2 Cumberland Street
Charleston, SC 29401

Printed in Great Britain.

Library of Congress Catalog Card Number:

For all general information contact Arcadia Publishing at:
Telephone 843-853-2070
Fax 843-853-0044
E-Mail arcadia@charleston.net

For customer service and orders:
Toll-Free 1-888-313-BOOK

Visit us on the internet at http://www.arcadiaimages.com

# CONTENTS

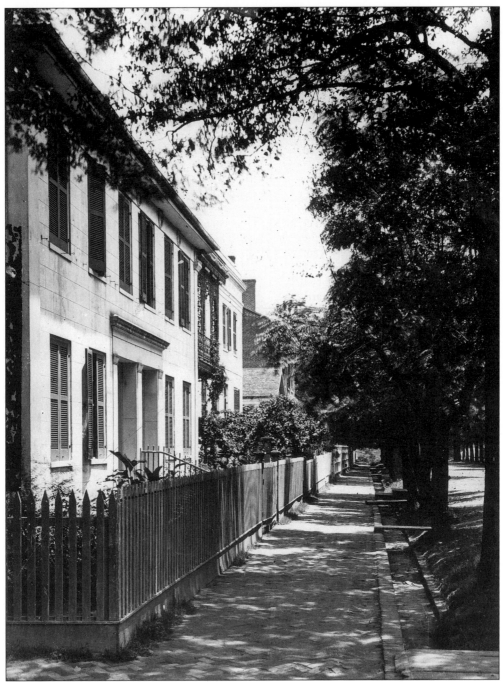

Pleasant neighborhoods surrounded the downtown commercial area of late-19th-century Natchez. Neat brick sidewalks, decorative fences, and towering shade trees enhanced the charming array of houses on streets such as this one photographed in about 1890.

# INTRODUCTION

A companion to *Natchez: City Streets Revisited*, this second volume, *Natchez:Landmarks, Lifestyles, and Leisure*, continues to highlight the work of photographers who worked in Natchez, Mississippi, for a combined period of about 100 years. Whereas volume one looks back at scenes and events on the city streets—throughout what is considered the traditional commercial center of town—volume two looks instead into the neighborhoods and suburbs and out into the countryside to show the lifestyles and leisure times of the people photographed during the late 19th and early 20th centuries. This second volume also takes the reader into the photographer's studio, where Natchez people of all ages and social backgrounds came to have the artist work the magic of his camera. The collection represented in the book includes the work of three photographers, plus a few images donated from other collections. The earliest of the three primary photographers, Henry D. Gurney, worked in Natchez from 1851 until the late 1870s. Young Henry C. Norman arrived in Natchez in 1870 at age 20 to begin his remarkable career. Norman started out as an assistant to Gurney, and, by the time Gurney was ready to retire from the business, Norman already had opened his own studio and was fast becoming a photographer of some renown. For more than 40 years, Henry Norman dominated photography in Natchez. He died in 1913 and was succeeded by his son, Earl Norman, who continued to operate Norman's Studio for almost another 40 years.

Natchez was a photogenic town for those who walked its streets and operated the studios during the early period of photography. With its modern beginnings in the announcement of the 1839 daguerreotype, photography spread rapidly to the United States. Bustling Mississippi River towns such as Natchez were obvious targets of the operators of the new sun-picture studios. In pre-Civil War Natchez, cotton plantation owners amassed fortunes of staggering size. Wealthy families built mansions and filled them with the finest furnishings found in the East and Europe.

In the years after the war, when Henry C. Norman came to Natchez, handsome new commercial buildings were rising on city streets as the town began to recover from the devastating and divisive years. Neighborhoods retained the charm and character of many generations' having lived there. Palatial homes of the pre-war wealthy, though in many cases in dismal repair, graced the landscape all around the city and around the countryside. What's more, the people themselves were photogenic, fascinating folk of diverse ancestry. Thousands of them visited the studios of Gurney and the Normans.

The collection of tens of thousands of negatives left behind by the three photographers began to come alive after 1960, when Dr. Thomas H. Gandy acquired the collection from Mary Kate Norman, Earl's widow. A busy physician, Dr. Gandy hoped to save some historical record of the town he suspected could survive in the negatives. Indeed, the history found in the collection continues to amaze and astound all who see examples from it even many decades later.

Together, the two volumes present an overview of the authors' favorite selections from their collection. This two-volume work follows other books and foreshadows more to come. In 1978, University Press of Mississippi published the first book by Dr. Gandy and his wife, Joan W. Gandy, *Norman's Natchez: An Early Photographer and His Town*, now out of print. The second book, also out of print, was published in 1981, *Natchez Victorian Children*. Dover Publications released the third book in 1987, *The Mississippi Steamboat Era in Historic Photographs*, which remains available through booksellers and from the publisher. In 1998, Arcadia released a remake of the book featuring portraits of children, *Victorian Children of Natchez*.

The meaning of this scene is unclear, perhaps even baffling. It is clear, however, that playful poses such as this one increased in popularity in the 1890s, when more and more amateur photographers bought Kodaks. A new word emerged from this era—the "snapshot." The snapshot obviously was as attractive an idea for the professional as for the amateur, as many such pictures are among Henry Norman's 1890s photographs.

# One
# FROM MAIN STREET
# TO THE SUBURBS

Henry C. Norman traveled with his camera from the commercial area of town, where many families lived above, alongside, or behind their businesses, to nearby streets lined with large and small brick, frame, and stucco-finished houses. Sometimes he looked with his artist's eye for patterns made by brick sidewalks and picket fences; sometimes he turned his eye to playful groups found along the way. From Main Street, Norman traveled down Union, Pearl, and Rankin Streets. He went to Wall Street and to Washington Street, to High and to Monroe. From neighborhoods abutting the downtown, he traveled to the suburbs, stopping at some of the great antebellum houses built from cotton fortunes earlier in the century. Some descendants of the wealthy cotton barons posed at once-grand houses—fallen into disrepair as a result of fortunes lost during the Civil War. Some posed on horses or in fancy carriages. Some remained inside as Norman captured portraits of their stately houses, which symbolized what the old South once had been for a privileged few. Norman also went inside many homes, where families gathered in parlors for special portraits. Families in more modest houses also came to porches and gardens to pose for pictures, often including family pets. Henry Norman, and later his son Earl, reveal a town in part still familiar to residents in the early 21st century; but they also show through their lenses some tragic losses to Natchez nighborhoods—some accidental and others carried out in the name of progress.

Main Street between Pine and Rankin was a shady block where some of the town's prettiest new residences stood in the 1880s. Henry Norman stood near Pine Street (in the 1990s renamed Martin Luther King Jr. Street) and looked west on Main, his camera barely catching the big Polkinghorne boot sign hanging over the street a few blocks away in the distance.

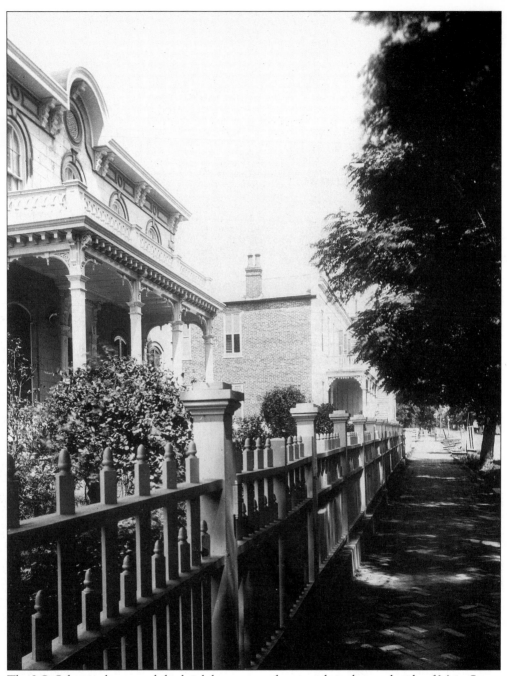

The J.C. Schwartz house and the brick house next door stood on the south side of Main Street between Pine and Rankin. Norman's artistic eye becomes evident in photographs such as this one, where light and shadow emphasize line and texture.

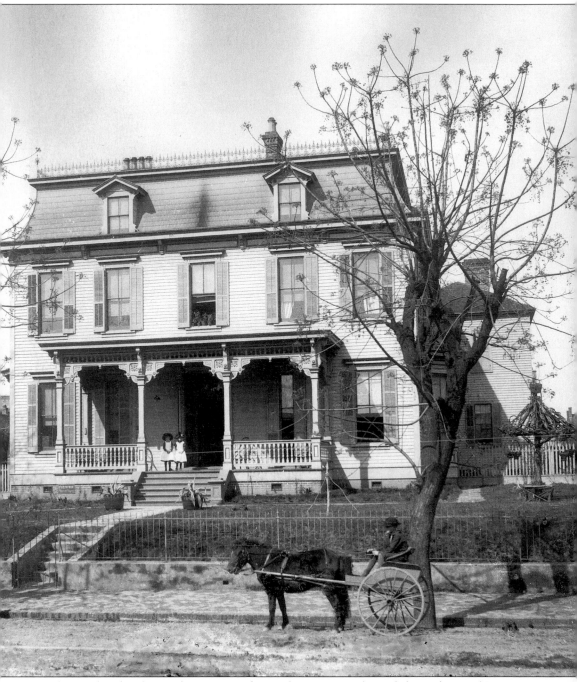

On the north side of Main between Rankin and Union was the stylish residence of Dr. J.C. French. A small boy poses in a pony-drawn cart in front of the house and two small girls stand at the top of the steps.

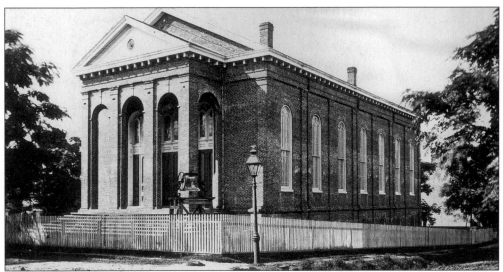

On the corner of Jefferson and Union Streets was the Jefferson Street Methodist Church, with its brick exterior not yet stuccoed and a fine picket fence surrounding it. Built in the 1870s, the church was home to one of the area's oldest Protestant congregations.

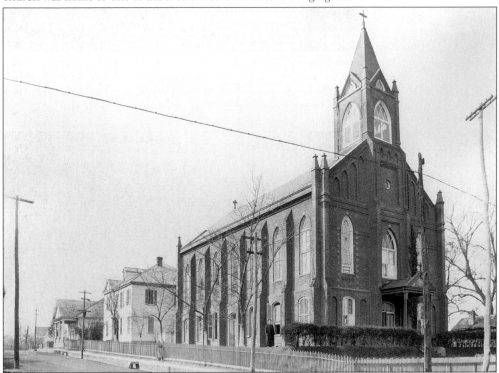

In 1894, the first Catholic church in Mississippi established specifically for black worshipers was built on the corner of St. Catherine Street and Orange Avenue. Holy Family Catholic Church continues today to serve as church home to many Natchez families. It also is the home base for the Holy Family Catholic Church Gospel Choir, who have for many years performed "Southern Road to Freedom" during Natchez Spring Pilgrimage as well as on many other occasions and in many other cities.

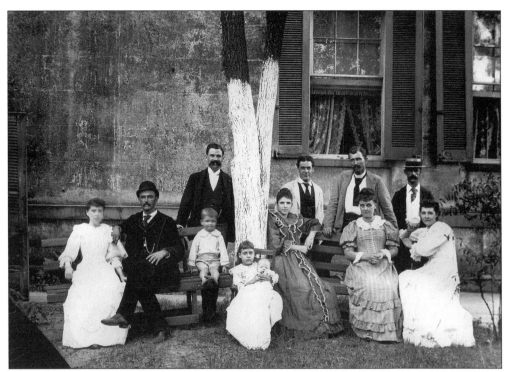

From Main Street only a block from the bluff park, Norman walked south on Canal Street and photographed a group outside the Banker's House, built by wealthy Natchezian Levin Marshall in the late 1830s when he built the Commercial Bank around the corner. The Main Street bank and Canal Street house shared a common wall and, in fact, a doorway through which the head cashier could go from home to work without going outside.

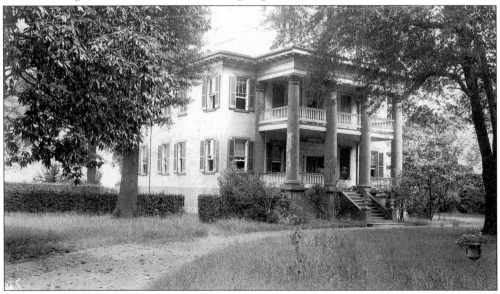

A grand Greek Revival-style mansion known in its last years as the Harper House stood on the bluff at Broadway and Monroe. Built in about 1840, the house was torn down in 1902 to make way for commercial development.

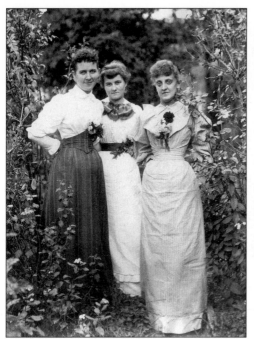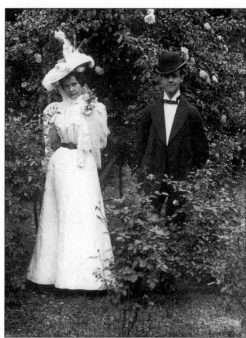

Miss Cole and friends, above left, pose informally in a garden setting. In another garden scene, above right, an intriguing couple, perhaps courting, send mixed signals with their expressions—he, quite pleased; she, quite disgusted. Andrews Patterson, below, appears in many Henry Norman photographs in the late 1890s and early 1900s, always demonstrating a jovial personality.

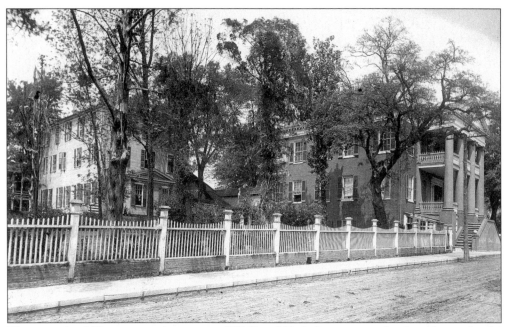

The grounds of Choctaw, at the corner of Wall and High Streets, were bordered by a splendid fence, as so many houses, churches, and other buildings were in the 19th century. A portion of the fence has been rebuilt in a meticulous restoration of the house in recent years. Stanton College moved to Choctaw from Stanton Hall in 1901, and many young women from prominent Natchez families attended the school in the early 1900s to the World War I era.

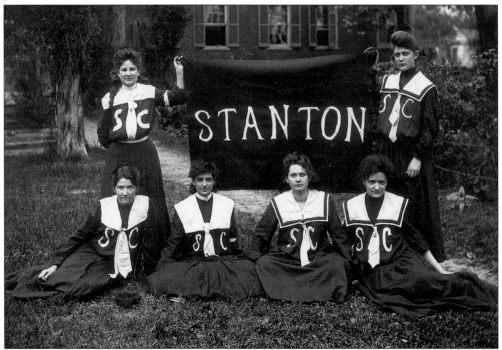

A group of Stanton College students pose with their school flag in about 1905. Holding the flag at left is Cecil Rawle, granddaughter of Frederick Stanton.

A block east on the corner of Pearl and High Streets, Henry and Melanie Frank pose on the steps of their home, Myrtle Terrace, with three of their 11 children—their oldest daughter, Carrie, and two oldest sons, Edgar and Herman. Henry Frank operated a successful wholesale and retail dry goods company. In addition, he was active in establishment of local railroads and in the cotton trade.

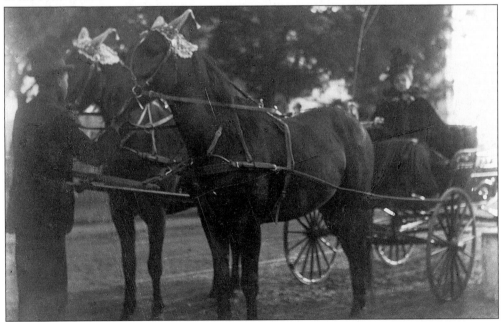

An amusing carriage scene in a downtown neighborhood caught the photographer's eye. Maybe the horses' decorative caps were the attraction.

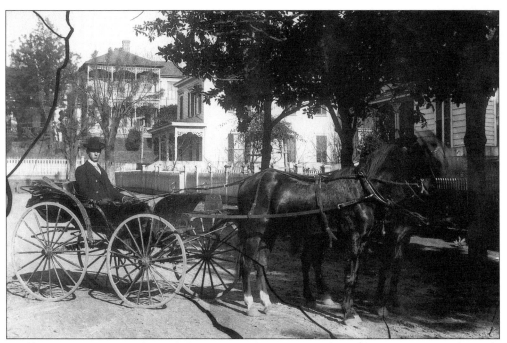

Hodding Carter pauses in his stylish carriage as he comes south on Commerce Street alongside Stanton Hall.

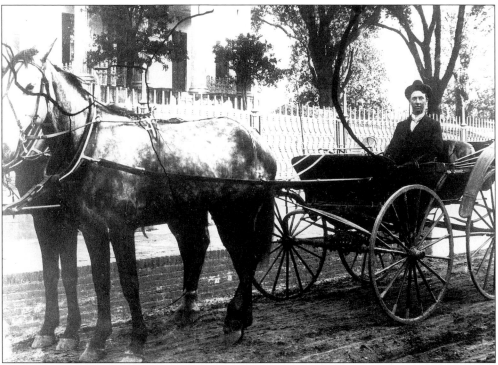

Carter, father of Pulitzer Prize-winning journalist Hodding Carter Jr. of Greenville, turns the corner and comes along High Street in front of Stanton Hall, stopping for another photograph after pushing his felt hat back on his head.

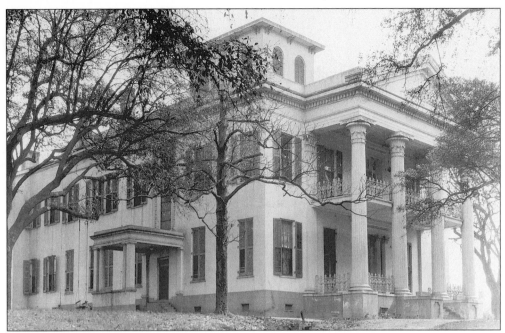

At another time, perhaps during the residency of the A.G. Campbell family, a photograph of Stanton Hall included the new porte cochere built in the early 1900s on the west side of the house.

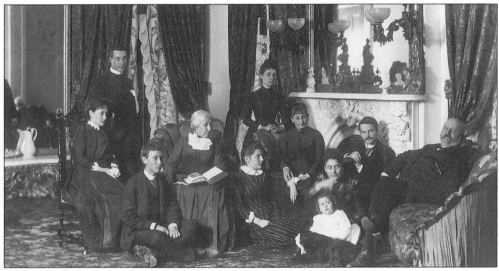

In 1888 or 1889, Hulda Stanton, the widow of Frederick Stanton, gathered her family about her for a portrait. Included are her daughter Elizabeth and son-in-law, John Rawle; the Rawles' three daughters (who married three brothers) and their husbands, Juliet and Lewis R. Martin, Bessie and William C. Martin, and Ethel and Farrar Conner Martin; the Rawles' daughter Hulda and her husband, Douglas Starke Bisland; young son John Rawle Jr.; and baby Cecil Rawle, born in November 1887. Frederick Stanton, a wealthy cotton broker and businessman, built the finely detailed Greek Revival-style mansion in the late 1850s. Only a few years after the Norman portrait was made, the family sold their home to proprietors of a girls' day and boarding school to be called Stanton College. The school moved to Choctaw in 1901.

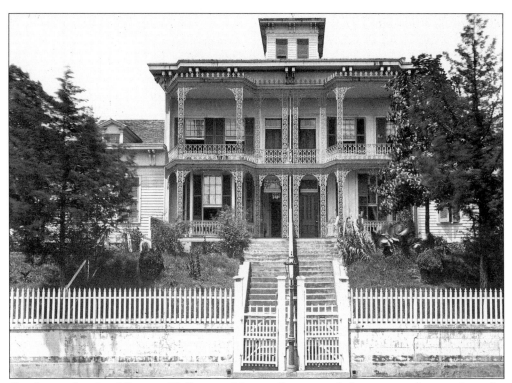

On the north side of Stanton Hall across Monroe Street stood the imposing house where the family of businessman and civic leader Lyman Aldrich lived. Reflecting a shift in taste to the Italiante style which began in Natchez during the last decade before the Civil War, the house presented an interesting contrast to many of the dwellings surrounding it. On the porch framed by ornate ironwork, some members of the Aldrich family, below, pose for the photographer in about 1880. The house and the hill on which it stood were torn down in the 1960s and a modern apartment complex built on the site.

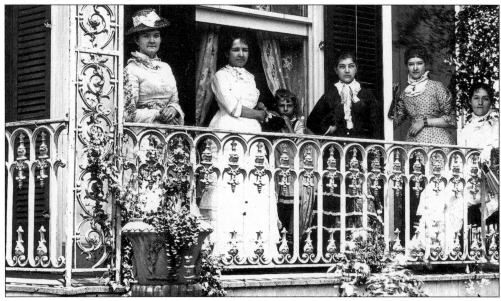

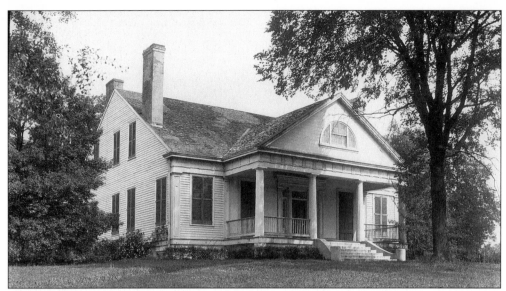

A few blocks north on Union Street, Norman photographed The Burn, built in 1836 and reflecting a nearly pure Greek Revival design. For many years, the house was home to the John P. Walworth family. Later owners added dormer windows which remain today.

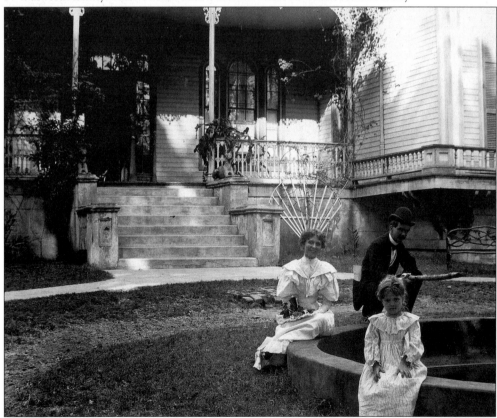

On the corner of Oak Street and Myrtle Avenue, a small group sits around the empty garden pool for a photograph in front of The Wigwam.

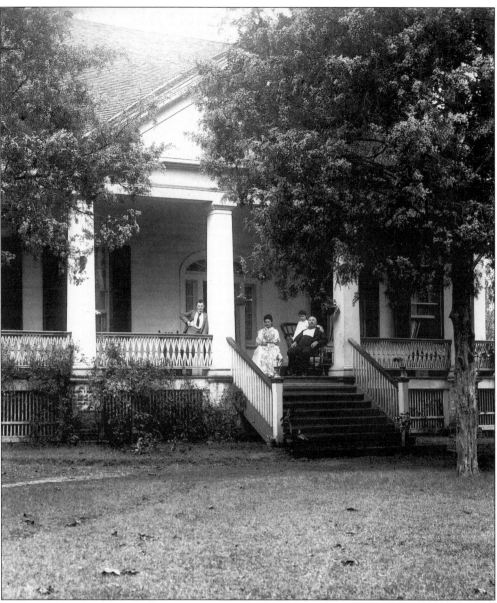

Half a block up Myrtle Avenue, Capt. Allison Foster and members of his family pose for Henry C. Norman at their home, Cottage Gardens. Foster, the county's chancery clerk, founded Foster's Funeral Home, which continued to operate in Natchez through half of the 20th century. Foster was among the prominent Natchezians in post-Civil War years to rally all residents to unity. In a booklet published in about 1888, he describes himself as a native of the North but won over by the South. He writes optimistically, "Sectionalism here, is buried in the dark gloom of the past, and its phantom, is not permitted to cross or shadow our pathway." He described his fellow townspeople as a "brave, united and devoted people." Norman could not have known that his son, Earl, would grow up to marry Mary Kate Foster, granddaughter of the prominent Capt. Foster.

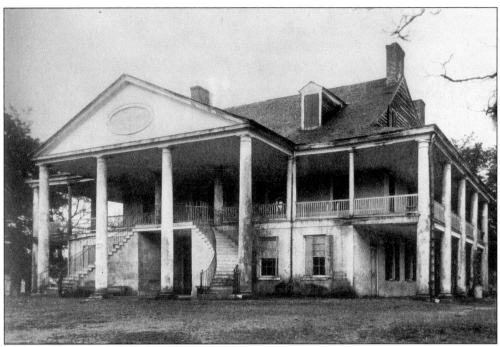

Henry Norman witnessed the loss of many fine old landmarks. One was Concord, built in the 1790s for Spanish Gov. Manuel Gayoso de Lemos. A later owner added the massive portico. The house burned in 1901.

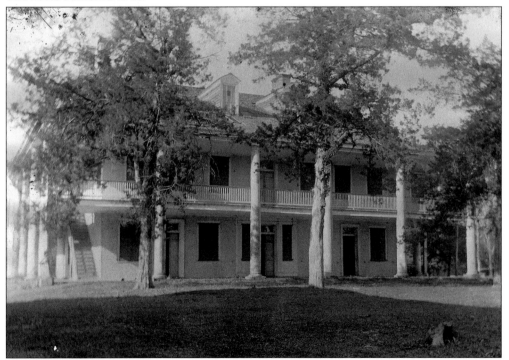

A rear view of Concord shows further the grand scale of the house, which stood in the north part of town a short distance to the east of Pine Street.

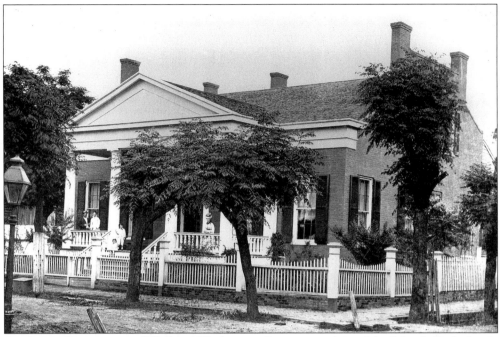

On the northeast corner of Wall and Washington Streets, members of the John A. Dicks family pose on the porch and on the steps of their home, known as Dixie.

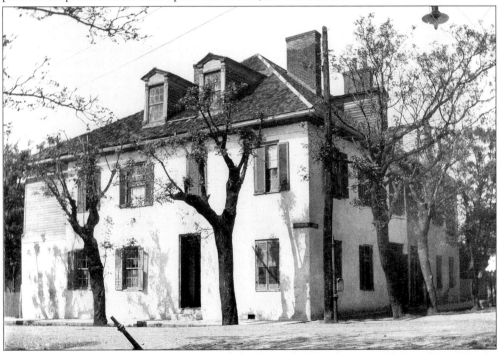

Texada stands across Wall Street from Dixie on the northwest corner of the intersection, its form and delicately detailed dormer windows intact but the brick exterior covered by stucco. Built for Manuel Texada about 1800 or shortly before, the excellent brick house stands beautifully restored today.

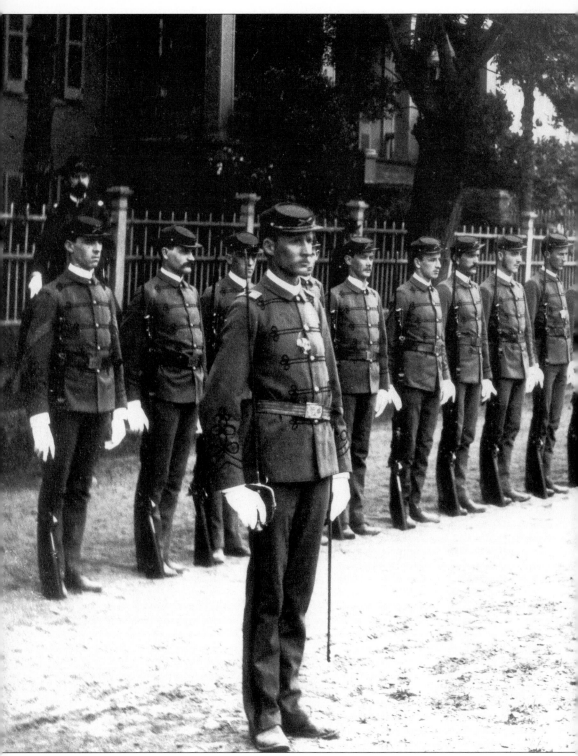

The Natchez Rifles, a volunteer militia, stand at attention during a parade on Broadway near the bluff park in 1888. Behind them is The Parsonage, a pre-Civil War mansion built at

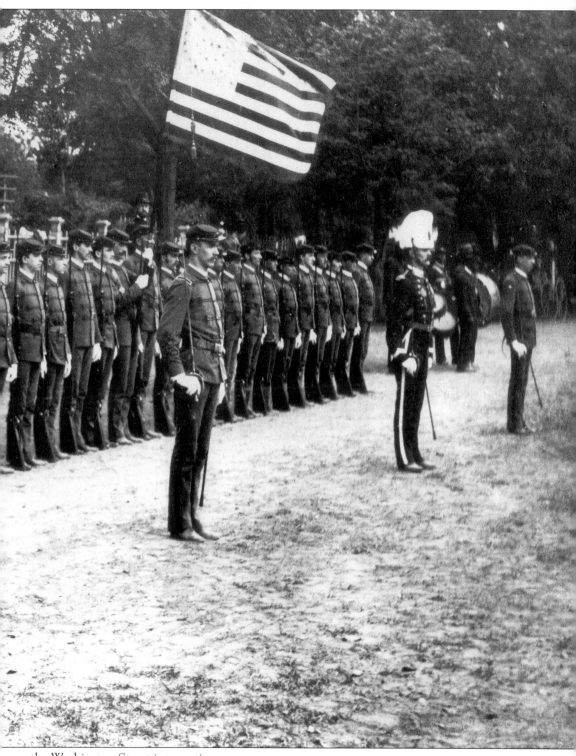

the Washington Street intersection.

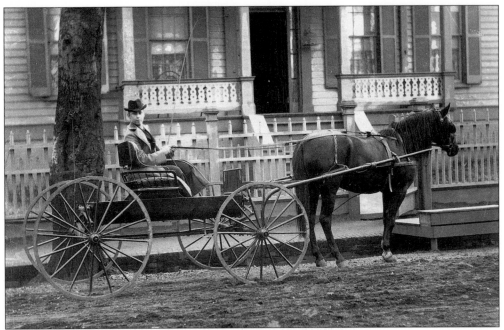

Ready for a ride, a Natchez man sits in his carriage in front of the picturesque cottage on the southwest corner of Washington and Canal, just behind The Parsonage.

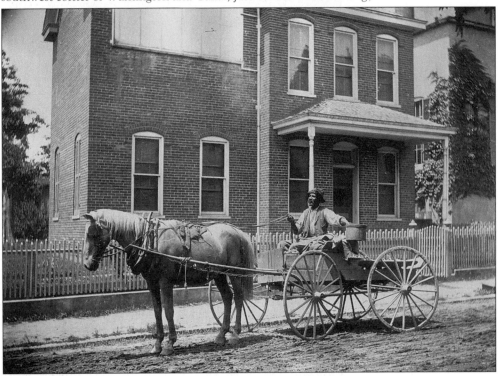

The vegetable farmer stops for a portrait during his morning rounds. The late John Dixon in the 1970s recalled from his childhood the farmer's melodious, rhythmic voice as he passed through Natchez neighborhoods calling out the names of the vegetables he had for sale.

Magnolia Hall stands on Pearl and Washington Streets, built by Natchez businessman and cotton planter Thomas Henderson in the late 1850s, only a short time before the beginning of the Civil War. Inside the stately Greek Revival-style mansion, young friends pose informally for a photograph. Many Norman photographs made in the 1890s reveal a more relaxed attitude on the part of those who posed. In photographs such as these, Norman not only provides important decorative and architectural details of the house but also a glimpse into the lives of people who lived and visited there in the late 19th century.

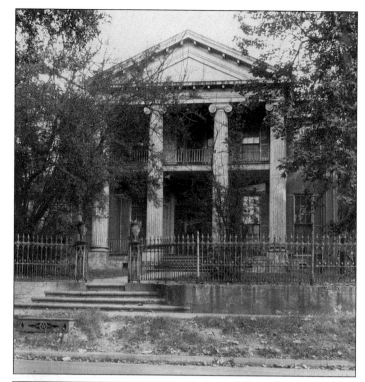

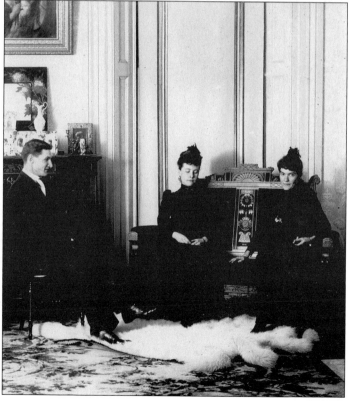

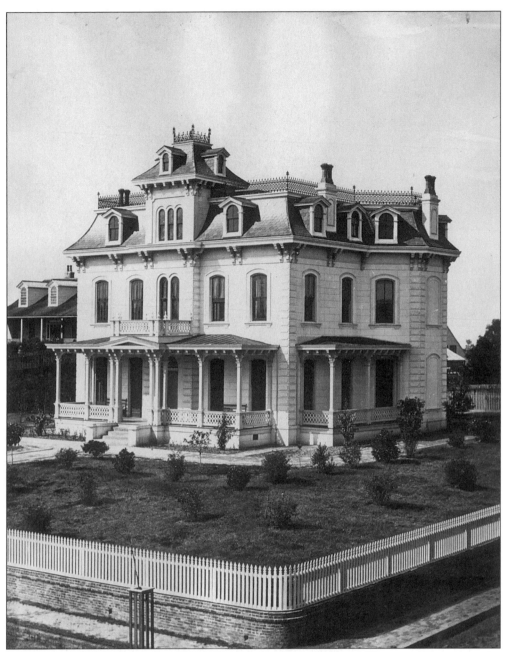

On the corner of Commerce and Washington is the house built by Christian Schwartz in the 1870s in the fashionable French Second Empire style. Today the house is known as Glen Auburn. In a recent restoration, the handsome fence was rebuilt around the grounds, further enhancing the setting of the Natchez landmark for those who view it today. To the left in the photograph is the edge of a house which once occupied the northwest corner of Commerce and Orleans Streets. When Henry Norman made the photograph, it was the home of the Isaac Lowenburg family. Around the turn of the century, the large half-block lot was subdivided and an attempt to move the old house resulted in its collapse, according to memoirs written by Clara Lowenburg Moses.

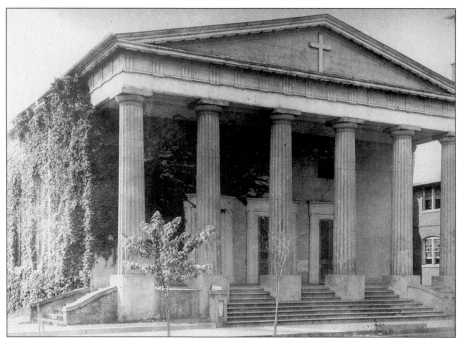

Churches frequently caught the photographer's eye, as did beautiful Trinity Episcopal Church on the southeast corner of Commerce and Washington. The church was built in 1822 but remodeled in the fashionable Greek Revival style in the late 1830s.

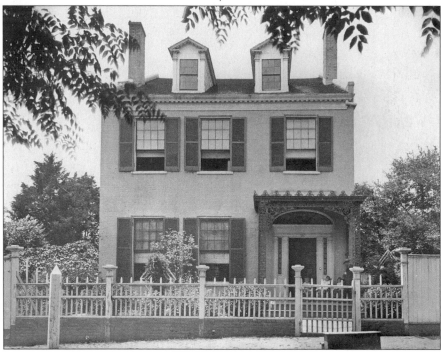

Further east on Washington Street, at Union, was the townhouse of Dr. Elias Van Court. According to the 1880 census, Dr. Van Court was father to 4 children. Perhaps the 3 oldest are the ones pictured on the porch with him: Katie, 6; Elias, 4; and Adlyne, 2. Baby Ann was 1.

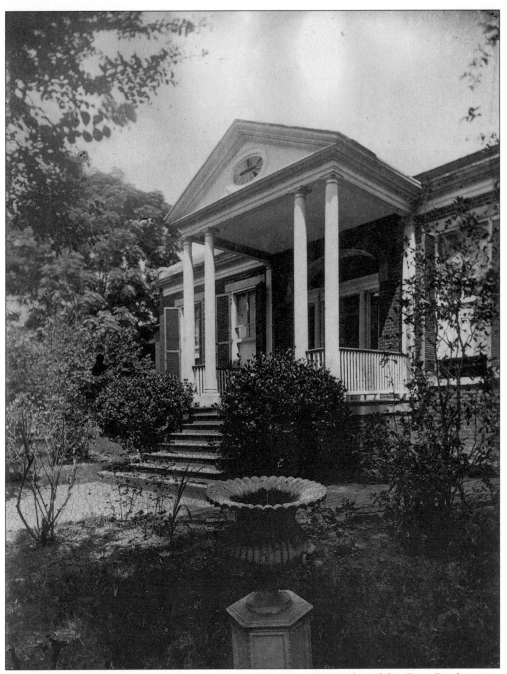

The Presbyterian Manse, next door to Green Leaves, was purchased by First Presbyterian Church in 1838 and since that time has been home to many ministers. The church continues to own the house, where the current minister and his family reside, at the corner of Rankin and Orleans.

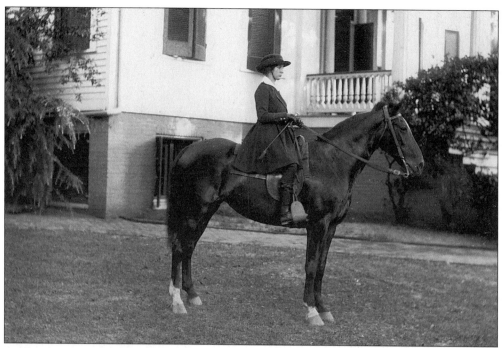

At Green Leaves, built in the 1830s at the corner of Rankin and Washington Streets, Virginia Roane Beltzhoover poses primly on her horse.

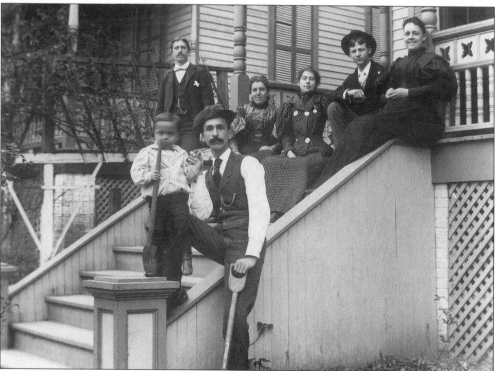

On South Commerce Street, members of the Byrnes and Wood family pose on the porch of their home.

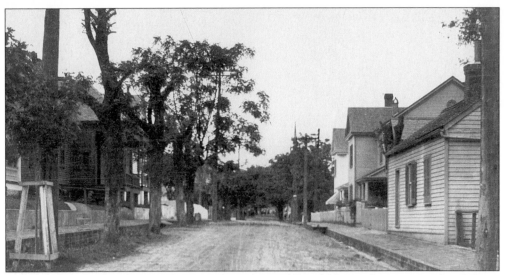

One street east, the photographer stood in the middle of Union Street near the Orleans intersection and looked to the north, where the very top of St. Mary's steeple rises above the trees.

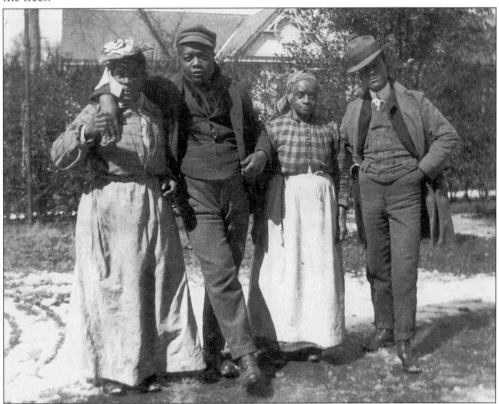

On South Union Street, the popular Natchez musician Bud Scott, second from left, poses with friends, including Lucinda Sharp, second from right. Scott and his orchestra played for several decades along the Mississippi River on boats and in towns. They played for Natchez galas and, during the band leader's last years, for the early Natchez Pilgrimage functions.

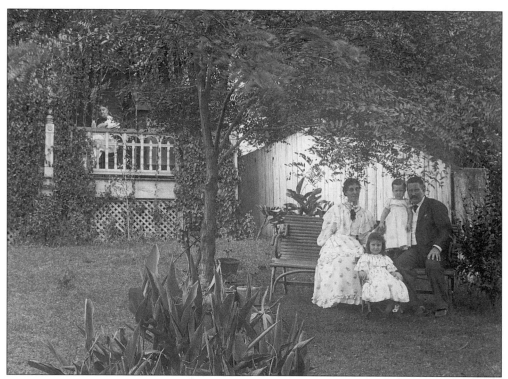

Many of Henry Norman's photographs reveal his wry sense of humor. Sometimes he expanded the scene in his lens to show not just those posing for the picture but also those watching from the sidelines. Is that Grandmother peeping through the vines?

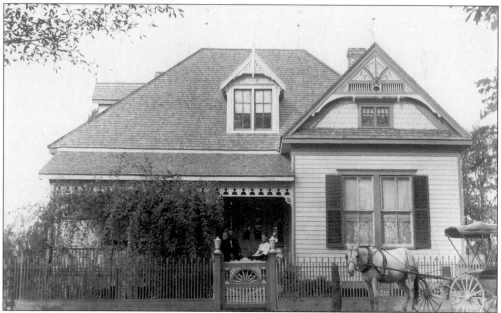

Animals frequently add another dimension to Henry Norman's photographs—certainly the horse does as it properly looks toward the camera along with Father, while Mother looks demurely in another direction.

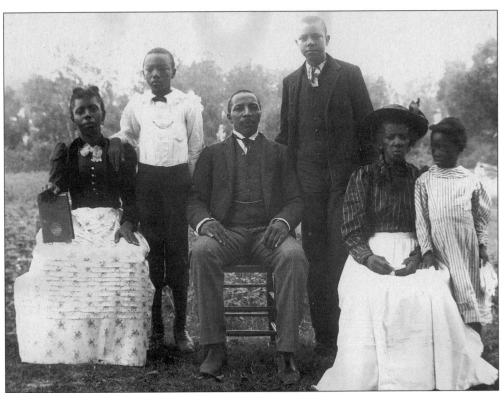

A group believed to be members of the Washington Miller family sits for a portrait. Miller ran a successful hack business in the late 19th century. The 1880 census shows that he and his wife, Emily, had three sons: James, 13; William 11; and Lloyd, 7. A daughter, Rachel Stanton, who was a schoolteacher, and her sons, aged 9 and 8, and daughter, age 4, also lived with the Miller family.

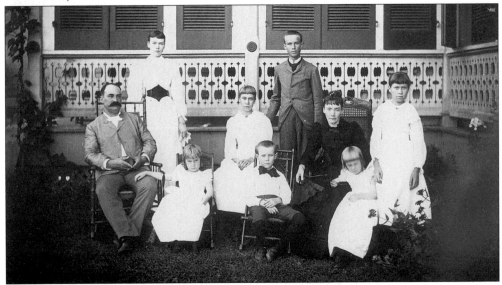

The Harper family gathers at the rear of their home, which still stands at the corner of Arlington and State Streets, a large, delightfully ornamented Victorian-style house.

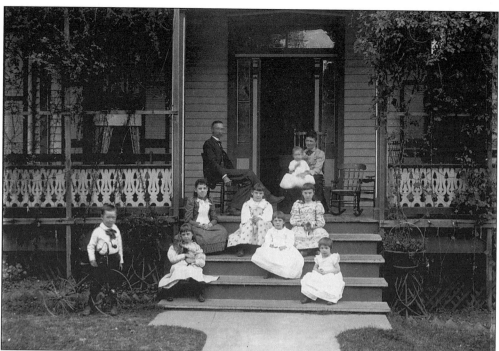

An unidentified family, above, relaxes on the porch and steps of their vine-draped house. Mother holds the baby; Father moves his head slightly, perhaps checking on the baby's status (the baby moved, also); two girls hold kittens; and Brother shows off a fine tricycle. The John Foggo family, right, chooses a shady garden setting for their portrait.

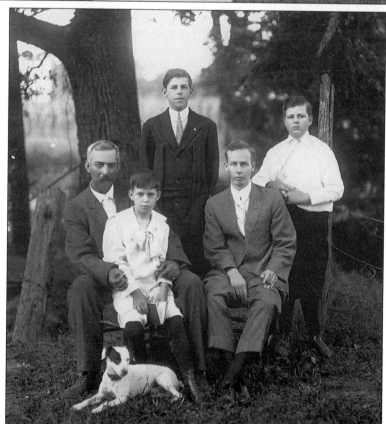

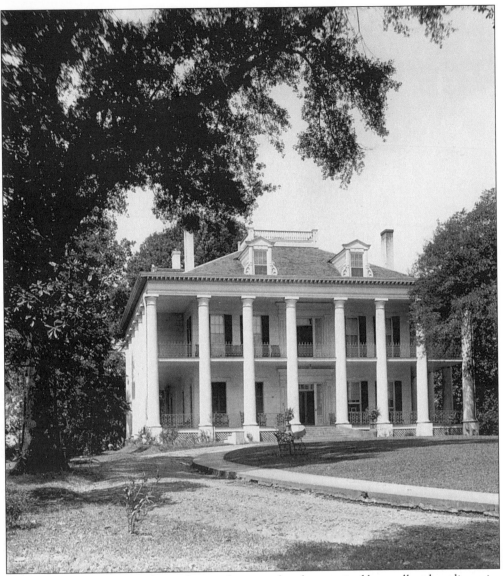

The suburbs hugged the outskirts of town, then as today characterized by small and medium-size residences interspersed among great expanses of property which were remnants of antebellum estates. One estate near the downtown area was Dunleith. The house was built in the 1850s, not long before the Civil War began, revolutionizing economic, political, and social life in the South.

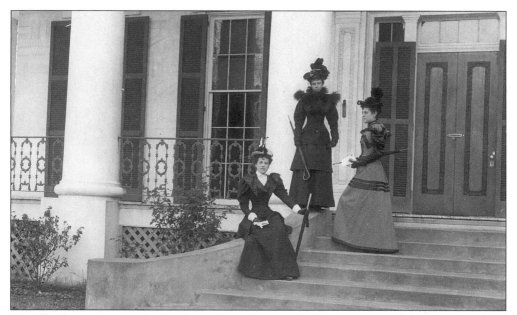

Camille Carpenter, at right, daughter of Joseph N. and Zipporah Carpenter, poses with friends on the steps of Dunleith in about 1890. The Carpenters were one of Natchez's wealthiest and most philanthropic families in post-war years. They are remembered especially for the donation of two fine public schools, Carpenter No. 1 and Carpenter No. 2, built on the north and south sides of town, respectively, in the early 1900s.

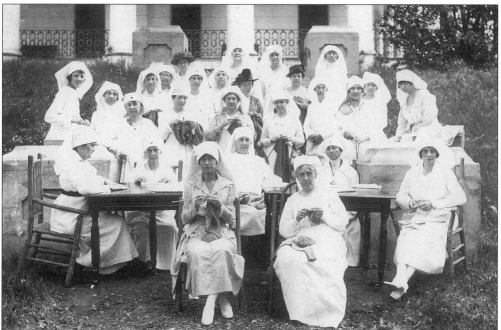

World War I prompted the formation of many Red Cross-sponsored volunteer groups, especially women who sewed and knitted as a way to help the war effort and to aid those made needy by the devastation. Natchez volunteers pose at Dunleith, where Carpenter family members were among those devoted to Red Cross efforts.

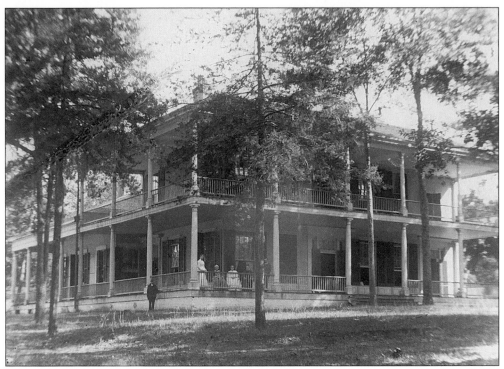

Close by Dunleith was Woodlands, built on a small hill also not far from the mansions Auburn, Ashburn, Routhland, Arlington, and Monmouth. The house burned in the 1920s and a mid-20th century subdivision named Woodland Park occupies the area today.

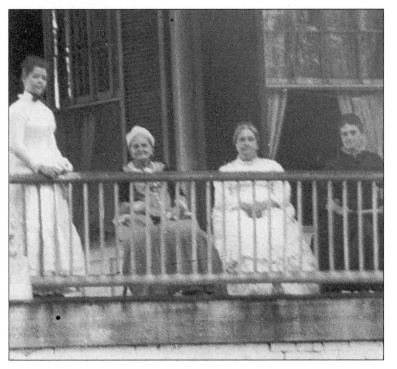

A close-up brings people on the porch into better view. The elderly woman, second from left, is Mary Louisa McMurran, widow of John T. McMurran, and former mistress of Melrose. Several tragic deaths in the family may have prompted the McMurrans to sell Melrose and move to Woodlands in 1865. Shortly after the move, Mr. McMurran died in a steamboat accident. Mrs. McMurran lived on until 1891.

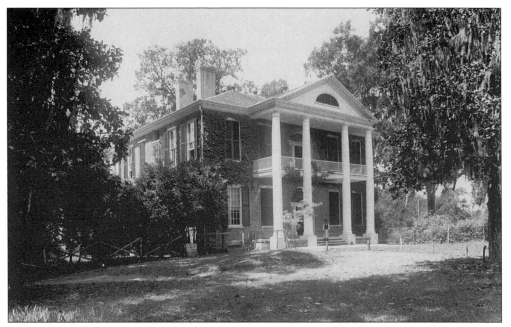

Arlington was built in 1818, one of the early grand mansions to feature the two-storied white-columned portico. Still standing today surrounded by extensive wooded grounds, the fine brick house is renowned for details such as the exquisite fanlights over front and rear entrances and marble trimming around windows and doors.

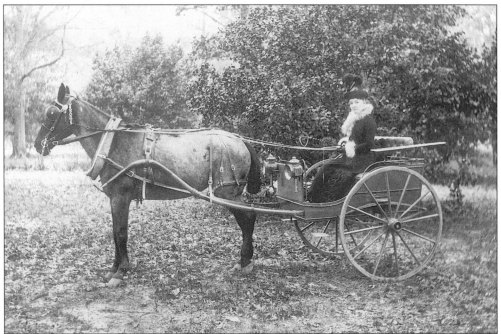

At Arlington, a member of the Boyd family, believed to be Nannie Boyd, sits in her very fine carriage for a photograph made about 1888. In his memoirs, *The Unhurried Years*, Pierce Butler, a family friend and contemporary who lived at Laurel Hill, describes Nannie Boyd as "really one of the most delightful and genuinely beautiful women I ever knew."

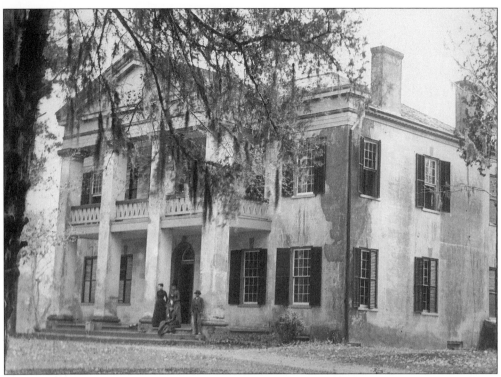

At Monmouth, descendants of the famous Gen. John A. Quitman, also a governor of Mississippi, pose on the steps of the 1818 house which was updated and enlarged by Quitman in the 1850s.

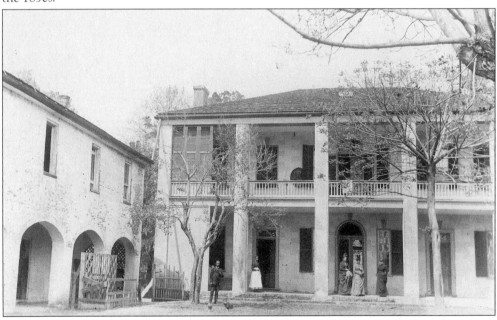

In a photograph of the imposing rear view of Monmouth made in about 1888, the grandeur remains despite the state of disrepair. The house stands beautifully restored today, embellished by lush, neat gardens all around the extensive grounds.

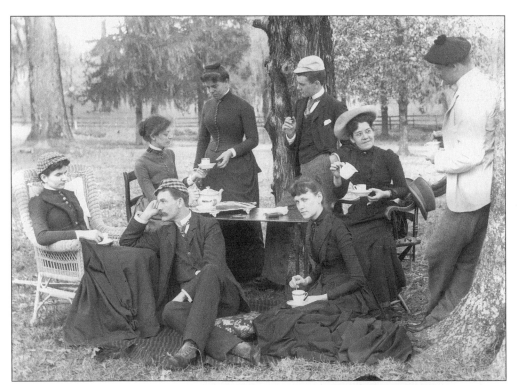

In the Monmouth gardens in about 1888, above, young people pose in a charming picnic scene, including Quitman granddaughters, the Lovell girls, and several cousins from the Conner family who lived at nearby Linden. Fannie Conner, right, concentrates on her needlework, probably lace making, as she sits on the porch at Monmouth in the 1880s. Many of the photographs made outdoors at homes during this era show how relaxed families were in bringing pieces of furniture—sometimes very fine pieces—to the porches or gardens to suit their activities.

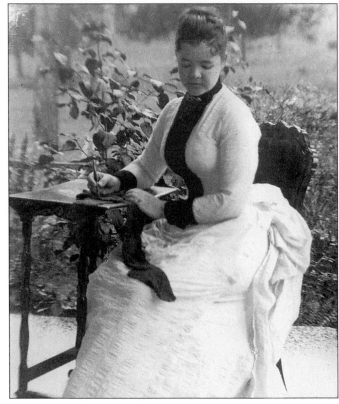

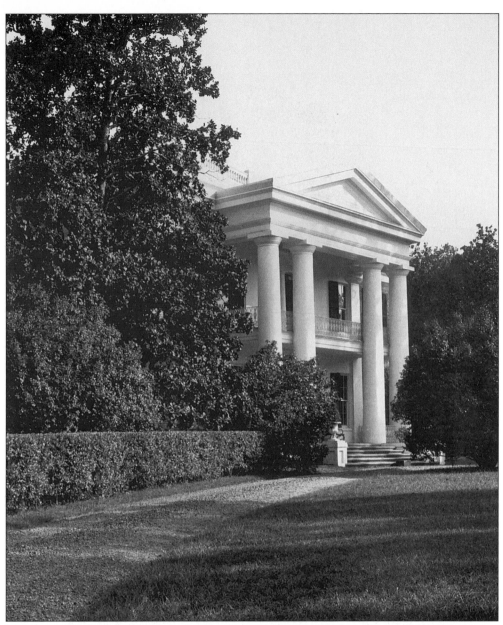

Melrose, ranked by many architectural historians as one of the finest Greek Revival mansions in the Deep South, was built in the 1840s for John T. and Mary Louisa McMurran. The McMurrans bought the best furnishings available for their new home and spent a few happy years there until the eve of the Civil War. The outstanding exterior and interior features of the house, including the preservation of many of the original furnishings, attracted the National Park Service to Melrose in the 1980s. A bill to authorize the establishment of the Natchez National Historical Park was passed in 1988. In 1990, the Park Service acquired Melrose; and Park Service specialists continue today an intensive research and restoration program there while keeping the house and grounds open to the public.

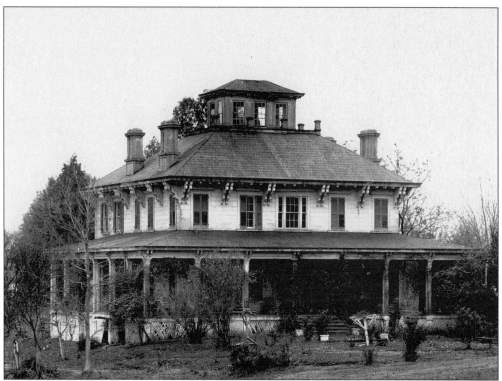

Italianate-style Llangollen, built by Charles Dahlgren in the late 1850s, caught the photographer's eye in the early 1900s. Llangollen in the late 19th century was the home of prominent Natchez attorney T. Otis Baker. Llangollen, which burned in 1932, was on the south side of town not far from Hawthorne and Longwood.

At Glenburnie, on the south edge of town, the Ogden family poses.

Agnes Shields, right, and her sister, Julia Shields, left, pose with an unidentified friend on a wide expanse of lawn. Agnes married George Marshall and spent most of her adult life as mistress of the country mansion Lansdowne.

# Two

# TO THE COUNTRY
# AND BACK

The countryside surrounding Natchez teemed with life in the late 19th century when Henry Norman set out to make photographs of all he could find. In the little community of Washington, he stopped often at historic Jefferson College, snapping memorable pictures of school buildings, students, and visitors. He stopped at the popular Pharsalia fairgrounds and recorded scenes of old-time fairs and horse races. And he went to Lansdowne Park on the other side of town for picnics and the momentous launching of a hot-air balloon. At Concord Park, an early aviator proved to be a photogenic subject. And throughout the travels into the countryside and back, Norman caught people on the porches of rural homes and general stores. He photographed solemn baptisms and jaunty baseball fans. He met others traveling country roads in their horse-drawn buggies and caught them with his camera. With a flair that seemed to come natural to him, Norman left a fascinating look into the lives and times of people who lived, worked, or played in country settings.

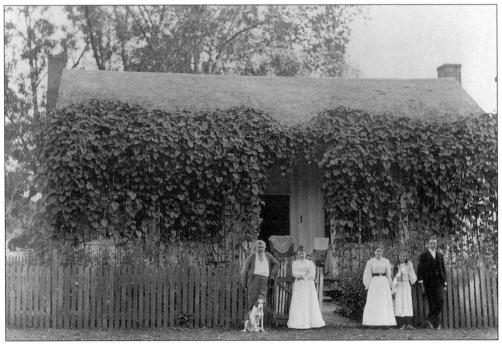

A Natchez family, including the winsome pet dog, poses at the picket fence in front of their vine-covered cottage in about 1900. Pleasant weather has arrived, no doubt. The rockers, perhaps pulled from the parlor onto the front porch, invite friends to sit and stay a while.

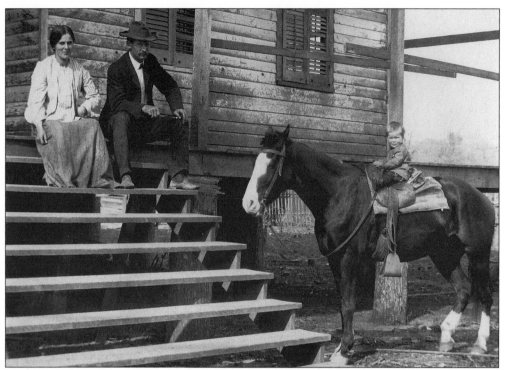

A very little boy experiences a very big moment, and the photographer is there to capture the occasion. Mother seems particularly proud; Papa tries not to let his pride show too much; and the little one performs very well as he sits alone and precariously high in the saddle.

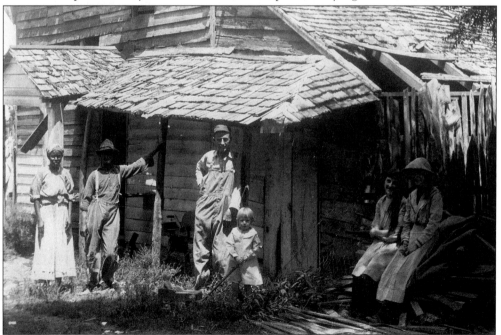

A congenial group visits behind the house, where the grown-ups take a break from work, the small boy pulls his toy wagon and the girls find a seat on the woodpile.

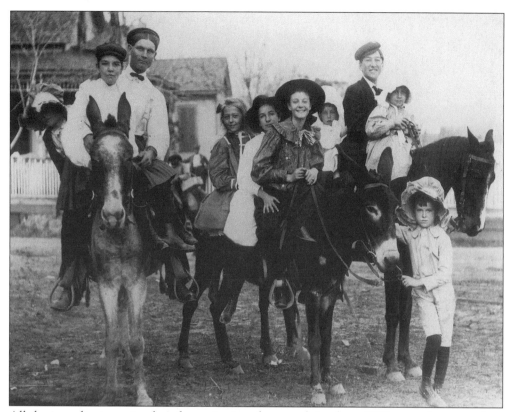

All the ingredients are in place for a winning photograph in about 1900—a mule or two, fun-loving friends and family, some smiles, and one smashing hat for the youngster who opted to stand in front.

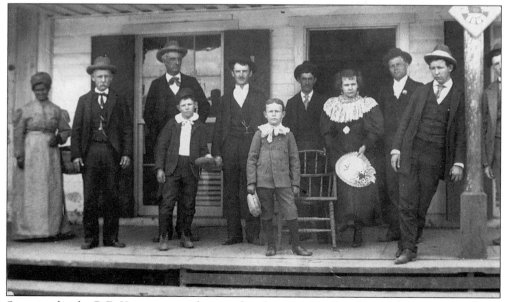

Stopping by the R.E. Yancey general store, the photographer found a good setting as well as a group not at all camera-shy.

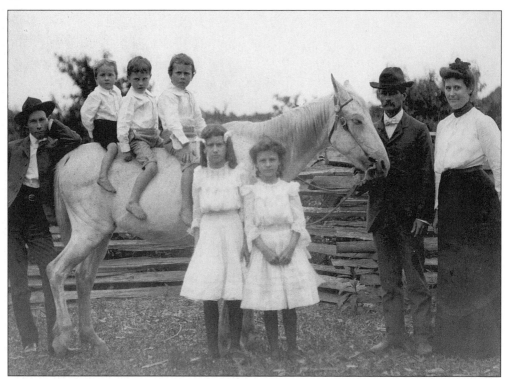

Serene through the whole ordeal, the faithful horse makes a photogenic prop for the country family's photograph, above. The same group, below, brings a very pleased grandmother—and grandfather, too—into the group for a picture made on the front porch of their country house.

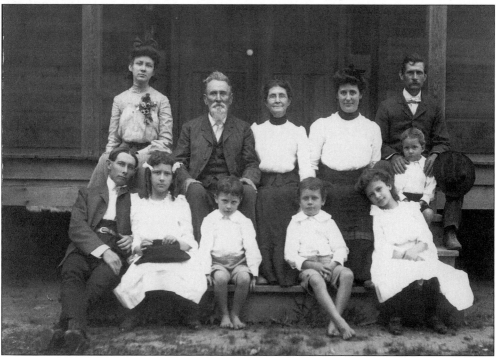

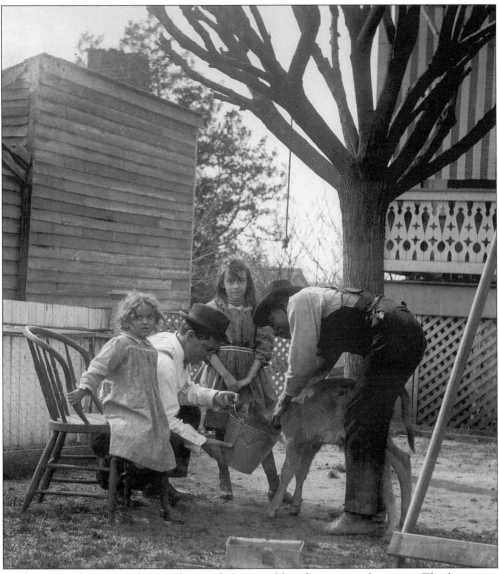

Feeding time for one of the small animals brings old and young to the scene. The busy men concentrate on their chore, and the calf surely is oblivious to all but the food bucket. The girls, however, cannot resist a look toward the camera.

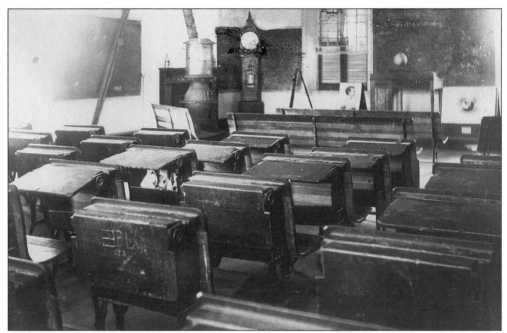

The old schoolroom bears the scars of many mischievous students, some having sneaked to cut initials in the desktops. For many youngsters of the late 19th century, schooling in a room such as this one was their only educational experience.

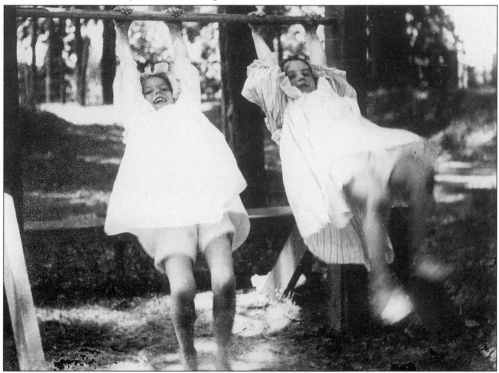

School's out and the weather's fine. Young girls swing joyfully on a summer day sometime in the early 1900s.

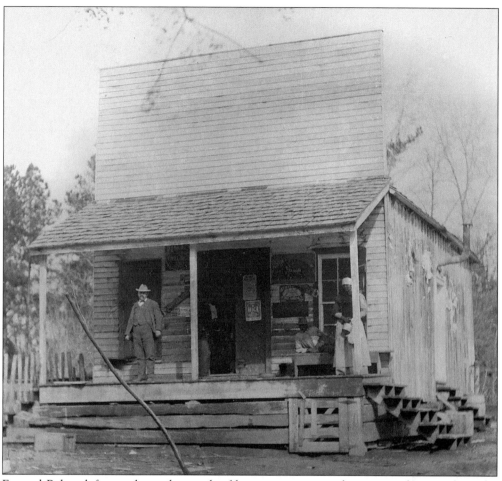

Everard Baker, left, stands on the porch of his country store, where many shoppers from the surrounding area came to buy weekly supplies of groceries and small household goods.

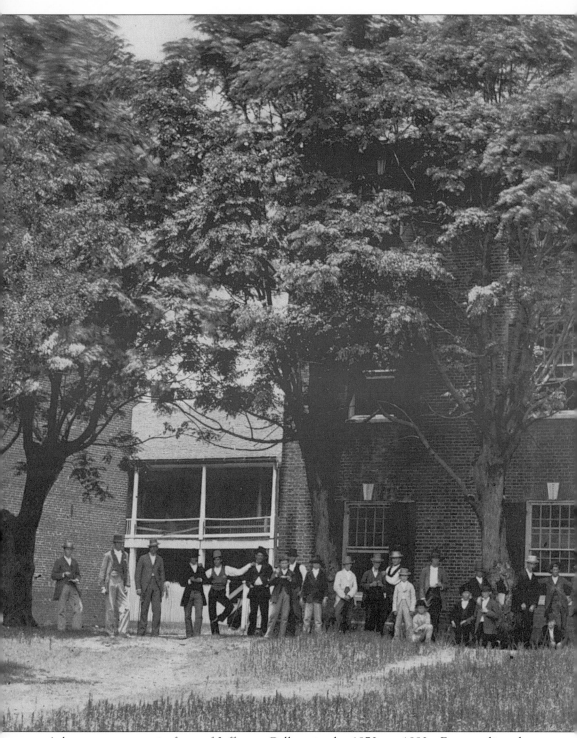

A large group poses in front of Jefferson College in the 1870s or 1880s. From earliest days, students were warned in their handbooks: "No student shall curse or swear, lie or get drunk or use improper or foolish epithets or indecent or profane language, nor wear a disrespectful or

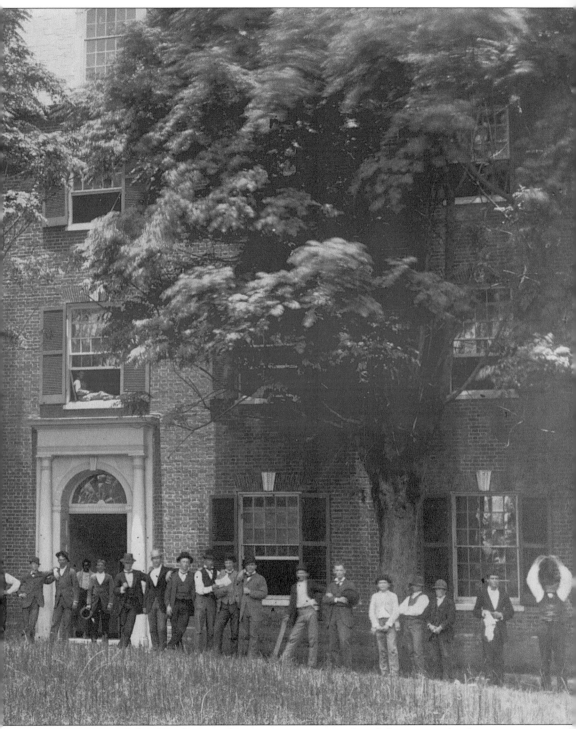

waggish air towards his Teacher or other persons, nor quarrel or fight or provoke the same in others."

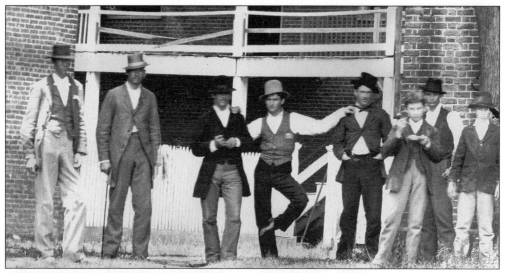

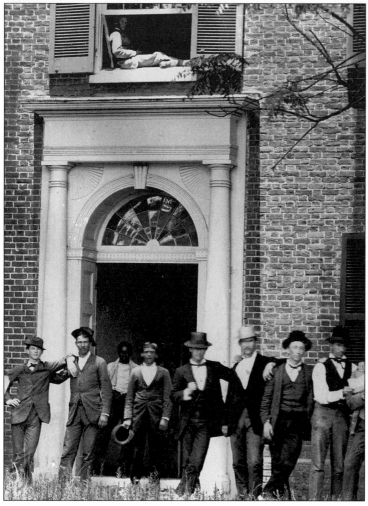

A closer look at the men lined up in front of the college, above, shows poses and expressions engaging to a viewer more than 100 years later. Hats, clothes, and mostly unsophisticated but perhaps "waggish" airs, left, prompt many questions about what the occasion might have been.

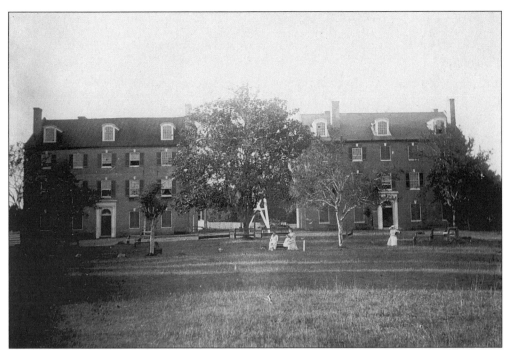

Henry Norman made many photographs of Jefferson College. The school was chartered in 1802 and opened in 1811 in one frame building. The beautiful brick buildings were built in 1820 and 1839. Norman caught a few visitors sitting on benches in front of the school in the 1880s.

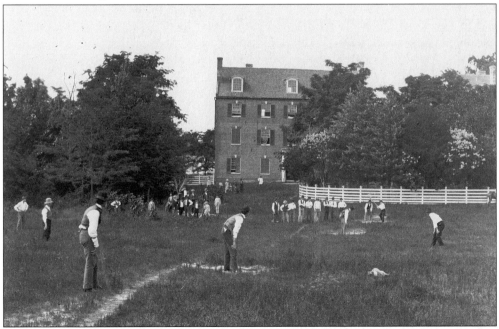

The Jefferson College baseball game is considered by some historians to be the first such game played in the Natchez area—maybe photographed in the 1870s. Batter is up. The pitcher is in position. Basemen stand ready. But onlookers appear not at all like today's rambunctious sports fans.

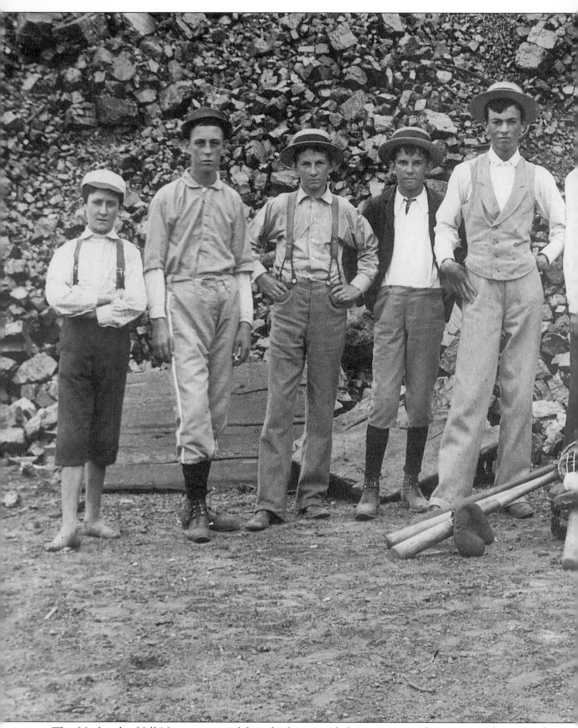

The Under-the-Hill Nine cast confident looks toward the camera as they pose with some of their baseball equipment. The nine—shown with a couple of their mascots on the side—played the game in the 1890s in Natchez with rival teams from other neighborhoods. Mark Twain said

of the game, "Baseball is the very symbol, the outward and visible expression of the drive and push and rush and struggle of the raging, tearing, booming nineteenth century." Perhaps Twain was right, but it's a good guess that the Under-the-Hill Nine simply liked to have fun.

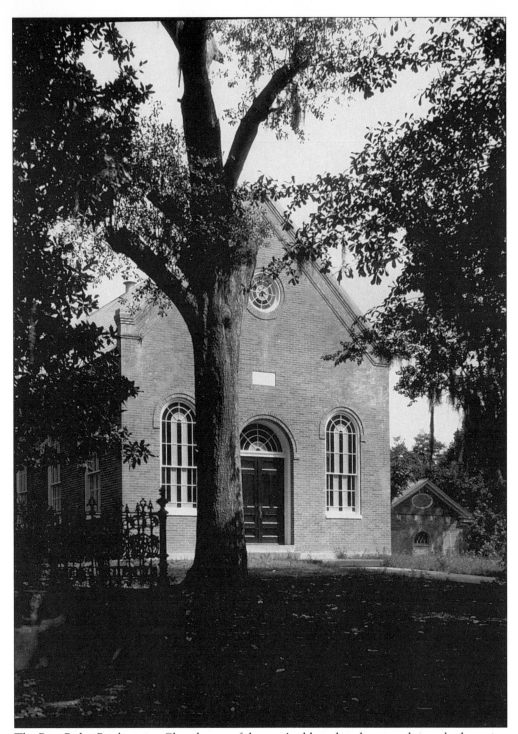

The Pine Ridge Presbyterian Church, one of the area's oldest churches, stands in a shady setting on Pine Ridge Road, its lovely brick session house to the right. The church building was destroyed by an April 1908 tornado, which heavily damaged other parts of the Pine Ridge community. The reconstructed church is pictured in this photograph.

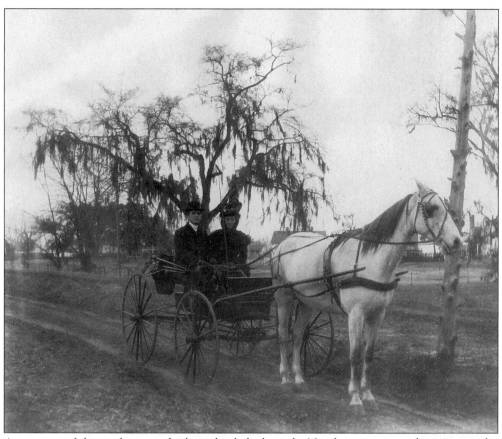

A variety of horse-drawn vehicles wheeled through Natchez streets and out into the countryside, always an attraction for someone with a camera.

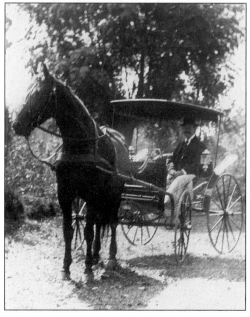

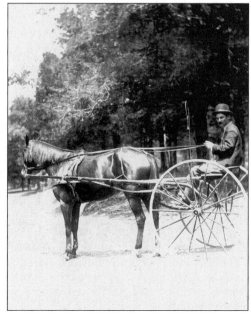

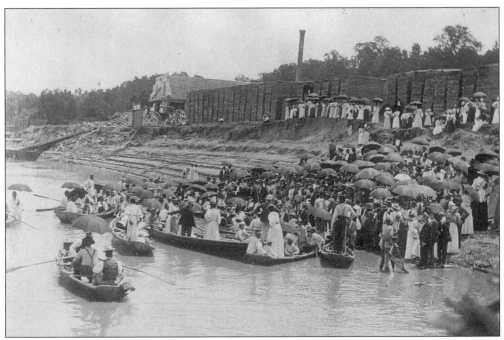

A baptism taking place in the Mississippi River near Learned's Mill, draws a large crowd. Most of the outdoor baptisms were sponsored by black congregations; but black and white alike came to witness the events.

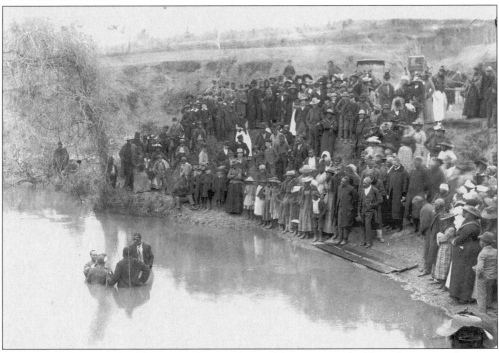

Preachers, helpers, and celebrants wade into the muddy water, marked by poles to guard against a step into deep water. As the baptism takes place, well wishers stand observant on the banks of a small pond or a quiet estuary of the Mississippi River in the 1890s.

During his travels around the area, Henry Norman made a stop at the old U.S. Marine Hospital, built in pre-Civil War days. From its cupola, he looked north toward Weymouth Hall on the left, with a bend in the Mississippi River just visible in his picture. Straight ahead, a couple of horse-drawn carriages come south on Cemetery Road. And, to the right, the historic City Cemetery stands shrouded by trees. Today the cemetery has expanded up to the location of the old hospital. The hospital building, right, in 1877 was home to newly established Natchez Seminary, a school for black students. In the 1880s, the institution moved to Jackson, where it grew into today's Jackson State University. The massive old building on Cemetery Road went on to serve many years as Natchez Charity Hospital. It was destroyed by fire in the 1980s.

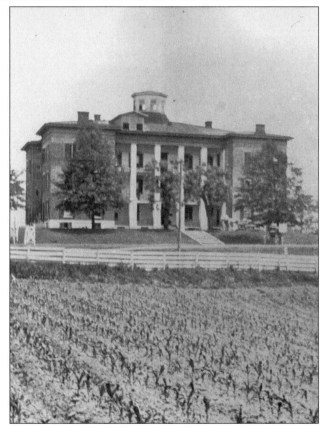

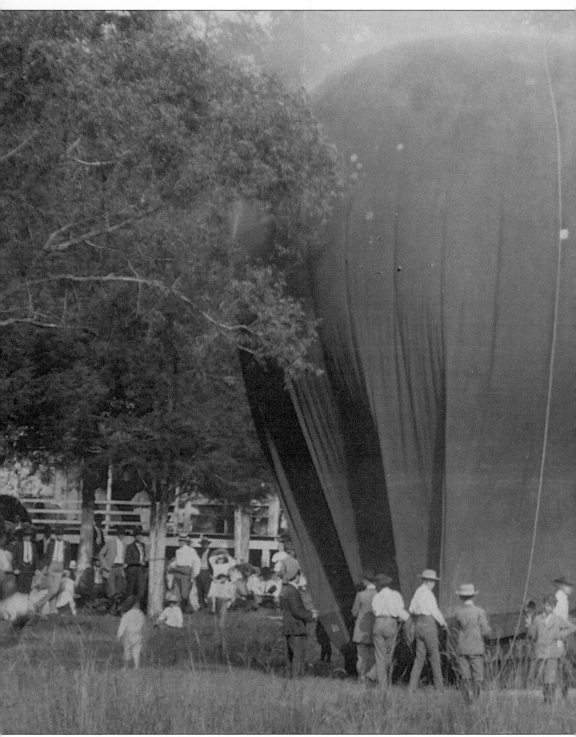

A hot-air balloon brings a large crowd to Lansdowne Park, where some spectators help to prepare it for flight. Smoke rose from the top as the exciting moment was drawing near. Women and girls in their summer dresses and hats throng to one side away from the excitement. Nearer

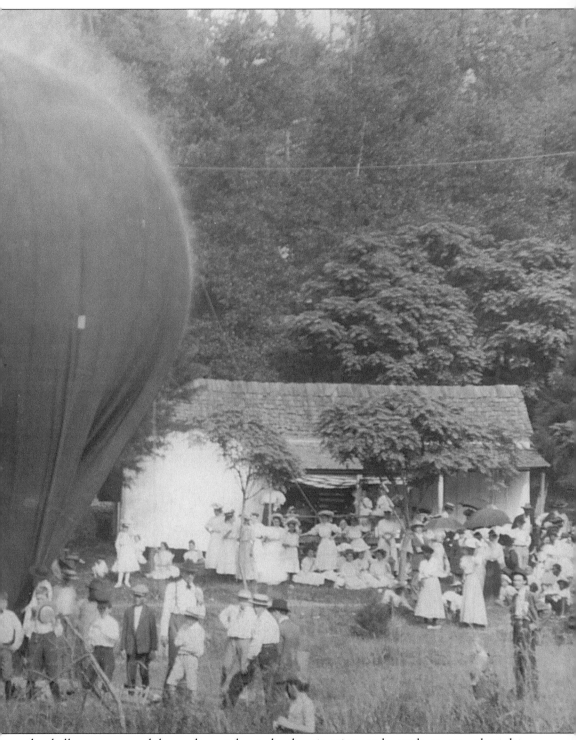

the balloon, men and boys alternately study the situation and watch to see what the photographer will do next.

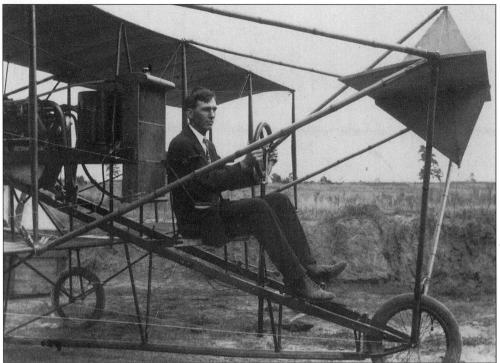

At Concord Park, Henry Norman—or perhaps his son Earl, who was working with his father by then—witnessed a big occasion in Natchez in 1912, when Lee W. Delaney brought his Curtiss bi-plane to town to offer free rides. He assembled the flying machine, made one turn about the town and crashed into a tree. The aviator came through unscathed but abandoned any thought of another flight, reports say.

A snapshot typical of the 1890s shows some young Natchez couples—very well dressed to be frolicking in the park—having fun somewhere along the river bluff.

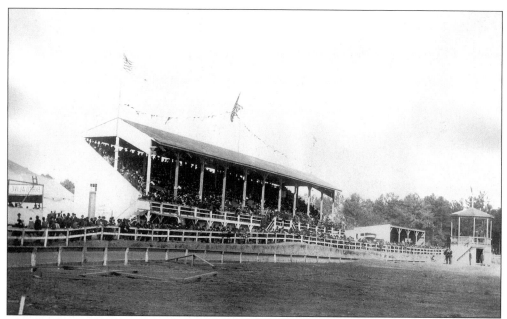

The stadium is filled to capacity and the rails are lined with onlookers as preparations get under way for the day's races. The Pharsalia fairgrounds and race track were popular in the 1880s and 1890s, when fairs, freak shows, and circuses operated side by side with horse races.

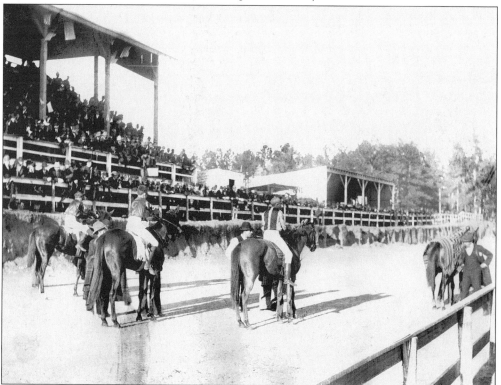

Lining up the contestants, officials give last-minute instructions to the jockeys who prepare for one of the day's races.

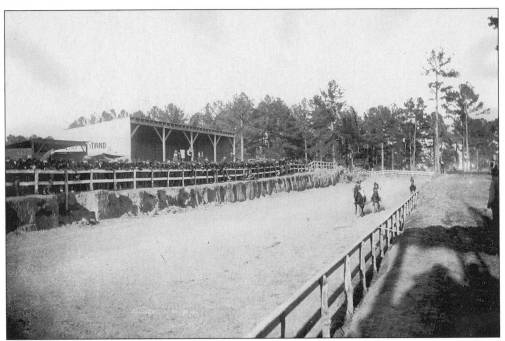

Making the final stretch, the horses race toward the finish line.

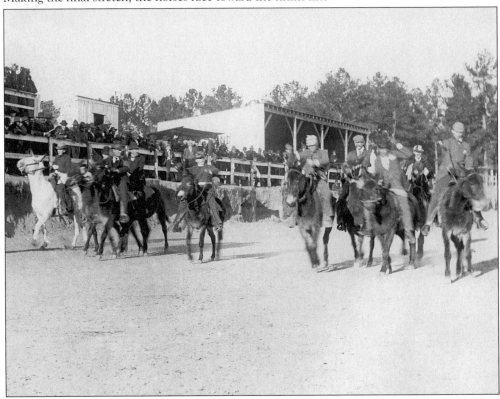

A race on mules was perhaps less legitimate but apparently plenty of fun for the Natchez men who mounted the mules and started the trek around the track.

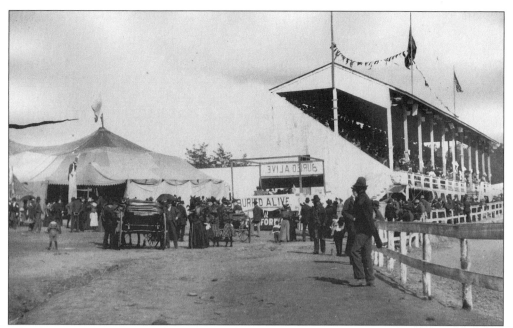

Next to the stands, a fair is under way, featuring such entertainment as "Buried Alive," and a man on stilts, near the tent opening at left.

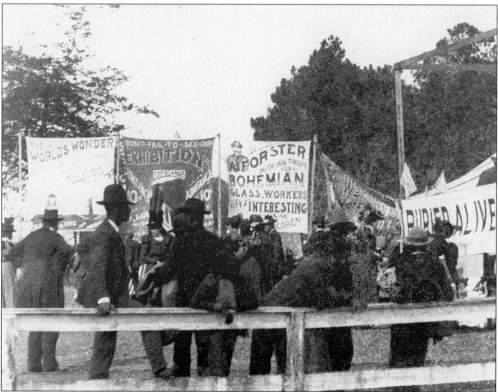

Big signs advertise special shows inside the tents, as fair-goers gather around to socialize as well as to visit the attractions.

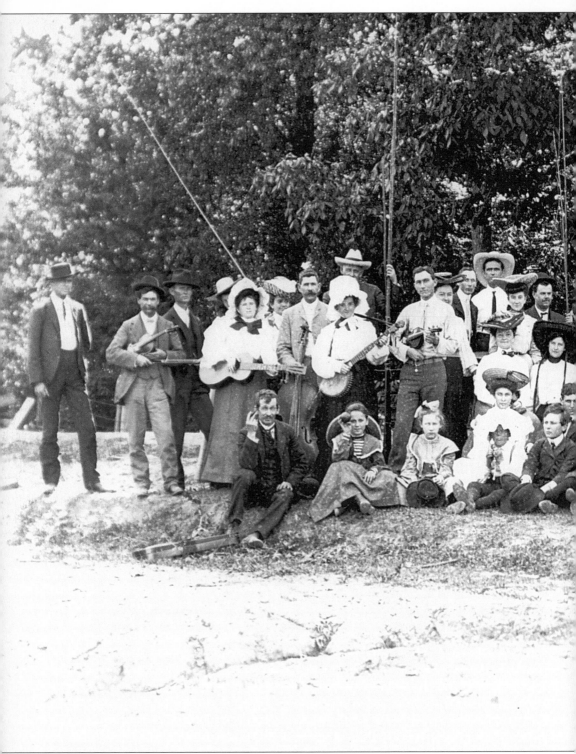

Fishing poles and fiddles bring thoughts of picnic food and plenty of good music. Was it a family reunion? A social club? A church outing? Whatever the occasion, the big group, gathered

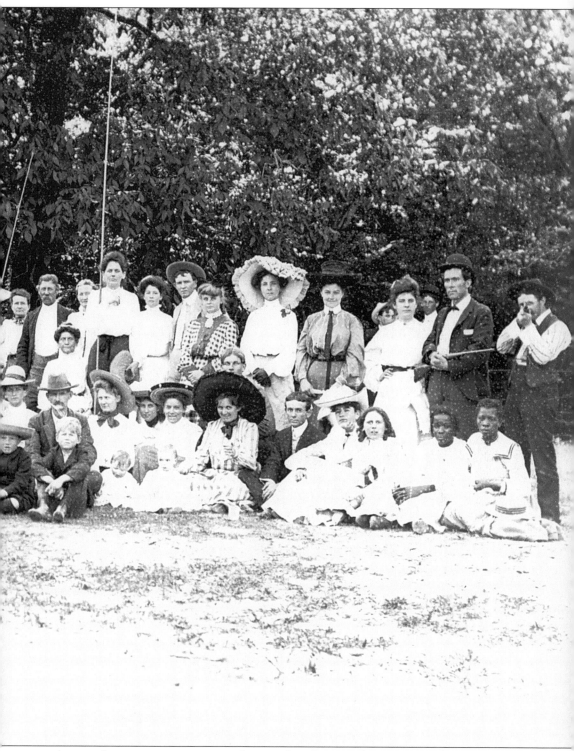

somewhere in the country, gives every indication that they were having an excellent time on a summer day.

Lansdowne Park, north on Pine Ridge Road near the house Lansdowne, was a favorite place for a picnic. Firemen, militia, and other men's social groups often chose the park for their Fourth of

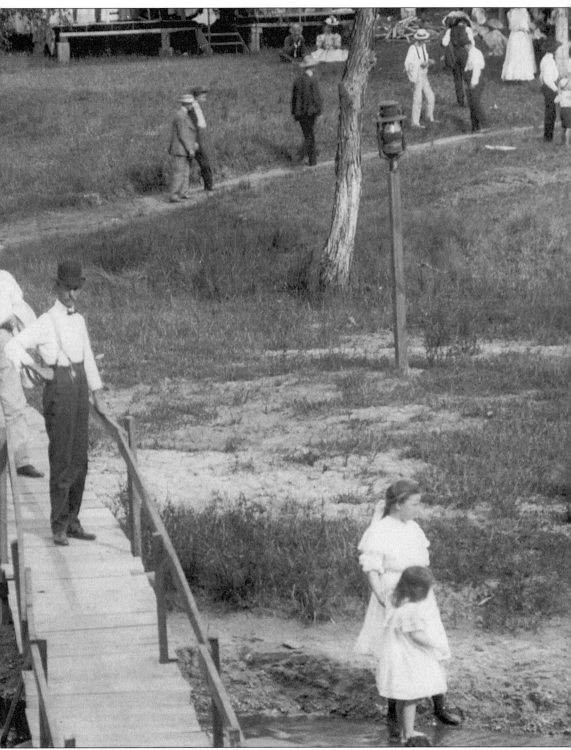

July celebrations. Cabins, pavilions, pathways, boardwalks, and plenty of space provided a perfect setting. To boot, a special train ran from town to the park for such occasions.

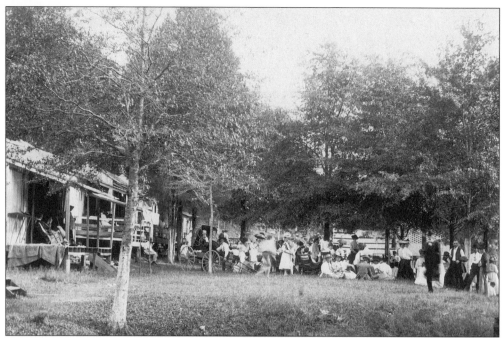

A large crowd relaxes with friends on the grounds of Lansdowne Park. A carriage without the horse provides a good view of the scene for a couple of picnickers. Others find shade on the cabin porches and under the trees.

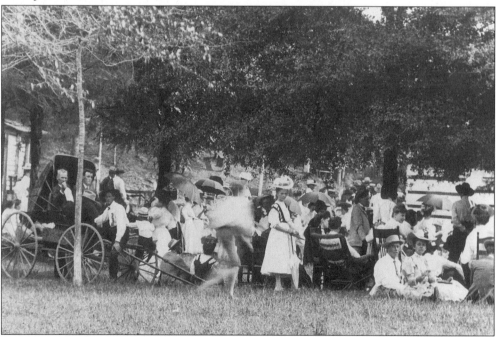

A closer view shows in the center of the picture a delightful summer outfit for a young girl, from her summer hat with turned-up brim to her frilly umbrella for walks in the sun. The close-up also shows parlor rockers which must have been packed in the backs of wagons or carriages and brought along for the day in the country.

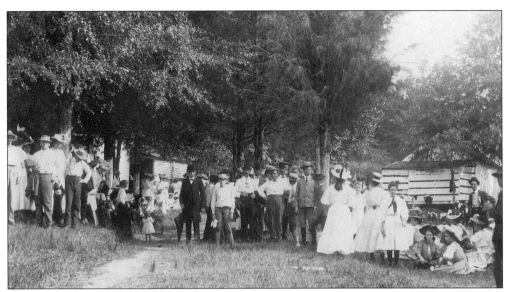

This outdoor gathering includes people of all ages. Some pose for the photograph, aware that the photographer is standing nearby focusing his camera. Others go on with the socializing, oblivious to the moment that will be frozen in time for viewing 100 or more years later.

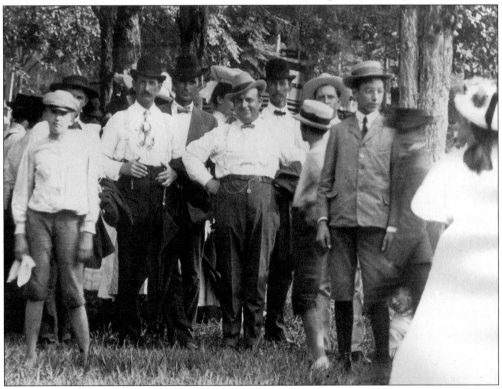

Another close-up reveals a young man, perhaps about to graduate from his knee pants and maybe just beginning to discover girls, casting an interested eye toward a group of young ladies passing by. Near his feet, a picnicker who has just figured out that the photographer is at work, finds space for a peep into the camera.

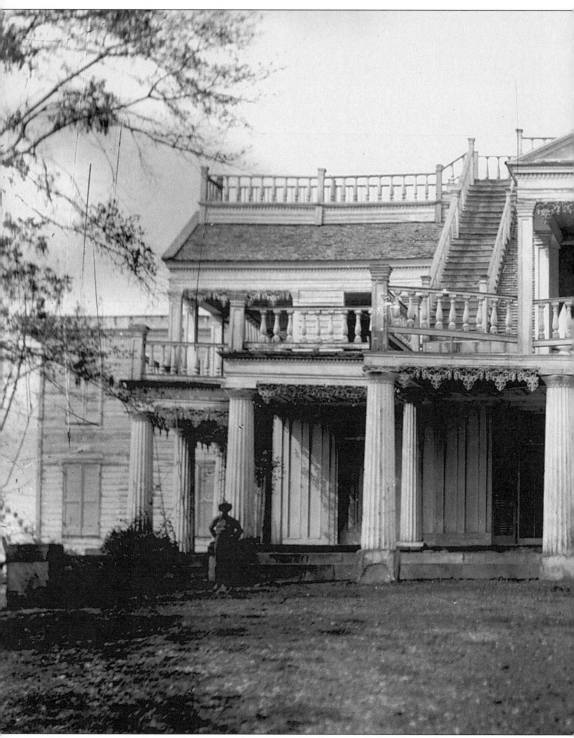

Mysterious and whimsical in its combination of architectural details, such a house as this one
was a natural for the photographer's camera. Some evidence indicates the house might have
stood south of Natchez overlooking the Mississippi River, but no positive proof has

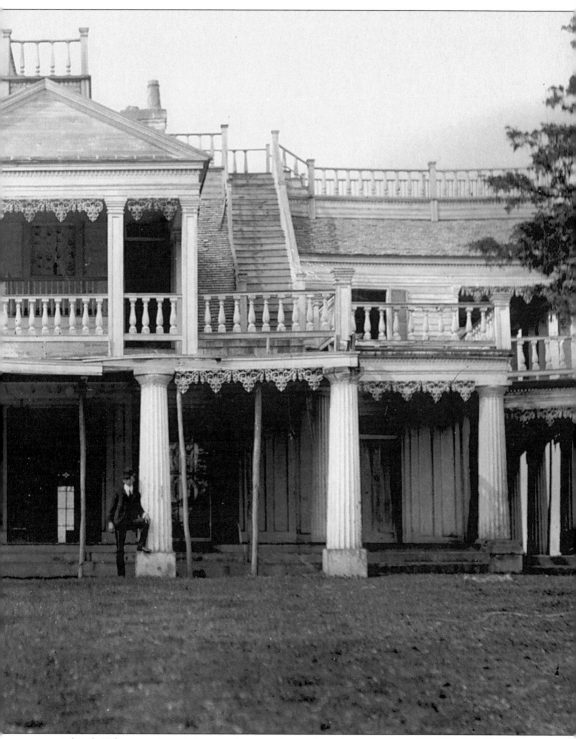

materialized. Whatever its origins or wherever it stood, its image today provokes thoughts and smiles.

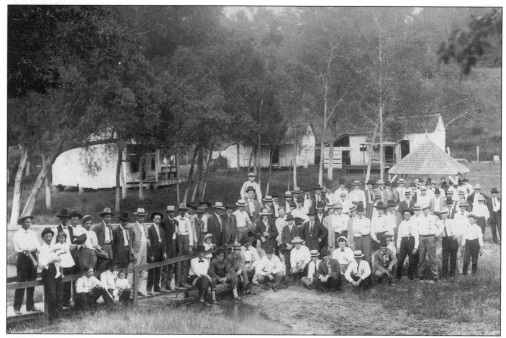

All the men gather for a photograph, perhaps at the end of the day's outing. The grounds and porches at the park are bare; and once more all the men don their hats for the final moment before the goodbyes.

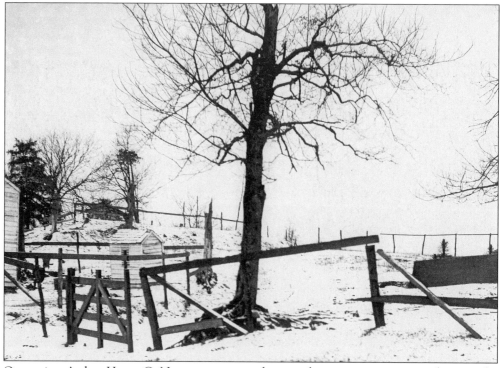

On a winter's day, Henry C. Norman stops to photograph a snowy scene somewhere in the country, where leafless trees and broken fences catch his eye.

# *Three*

# THE PEOPLE POSED AND POSED

People came from all around the town to have portraits made at the photographer's studio. With the advent of artists with cameras, just about anyone could afford a portrait. What's more, the sitting and posing for a picture took much less time than with the portrait painters who frequently traveled in and out of towns such as Natchez in the 19th century. Nevertheless, in earliest days of photography, the new medium was intimidating to some would-be posers. After all, how could such a real likeness be anything but magic, they wondered. Most doubters soon relaxed, however, and put on their Sunday best for the trip to the studio. Men, women, children, sisters, brothers, whole families, and costumed participants in some of the era's colorful theater productions came prepared to pose. Well-known Natchezians such as mayors and clergymen came. Members of the most prominent families came. Dressed in Egyptian, Swiss, Japanese, and other elaborate costumes, actors in the extravaganza called *The Kirmess* came to pose for Henry Norman. And many of less fame and fortune but with astounding presence and charm sat for their photographic portraits. Norman was an especially talented portraitist, having the ability to capture the essence of a personality with his camera. A Natchez booklet, published in the early 1880s, refers to Norman as "happily endowed with the instinct of art as well as chemical genius" and a photographer who is "just as painstaking with his small orders as with the extensive ones." Indeed, Norman demonstrates remarkable consistency in the quality of his portraits, particularly those made in his heyday—the 1880s and 1890s.

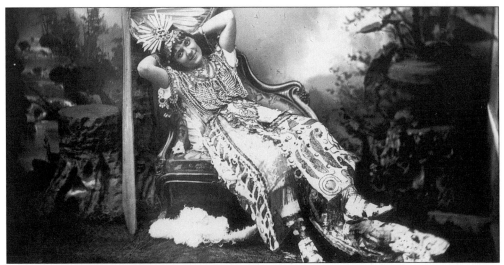

Illuminated by electric lights at Thomas Reber's Forks-of-the-Road Casino, *The Kirmess* in 1887 featured Mary Britton as Cleopatra, Queen of the Nile. The show featured 150 actors and actresses, all local amateurs, performing in tableaux to represent the nations of the world. "The Sorceress of the Nile, in her height of splendor, with the wealth of Egypt at her feet, never rivaled our Queen," the local newspaper opined following the first performance.

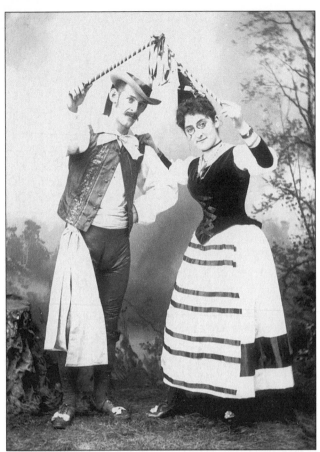

Clara Lowenburg and her uncle, Joseph E. Johnston Mayer, left, represent the Swiss in *The Kirmess*, performed to raise money for charity. Clara writes in her memoirs, "I danced with Uncle Joe in peasant costume in a Swedish dance and in German wooden shoes." Mayer was born during the week the USS *Essex* shelled Natchez in 1862. His parents named him in honor of Confederate Gen. Joseph Eggleston Johnston. The Mexican Band, below, played for *The Kirmess*. Clara continues in her memoirs, "We practiced dancing every night at the hall at the fair grounds. We all went in the street cars; we made our own and the boys' costumes. A very fine band of Mexican musicians that had been stranded in New Orleans after the big Cotton Exposition there, came to Natchez to play for the Kirmess."

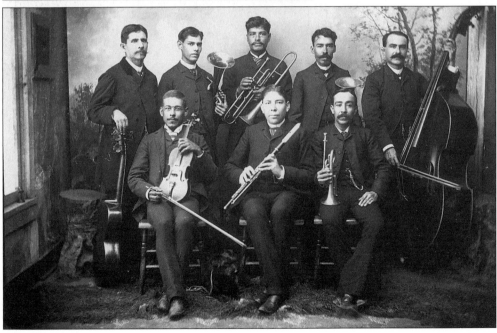

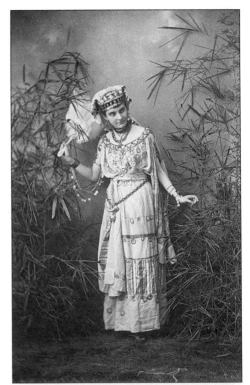

Miss Minor, right, with her elaborate costume and dramatic pose, brings to life the role she played in the popular 1887 show *The Kirmess*. Two of Frederick Stanton's granddaughters, below, Juliet Rawle Martin, standing at right, and Bessie Rawle Martin, reclining, are among the group representing some of the Far East nations in *The Kirmess*.

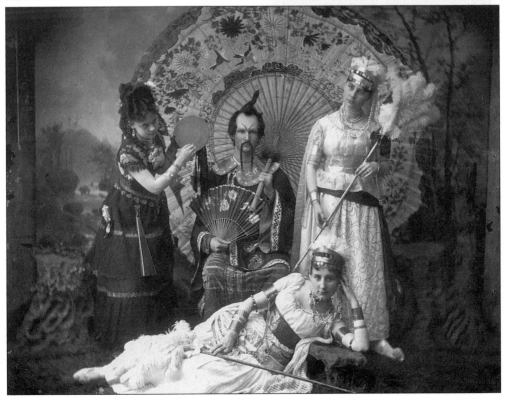

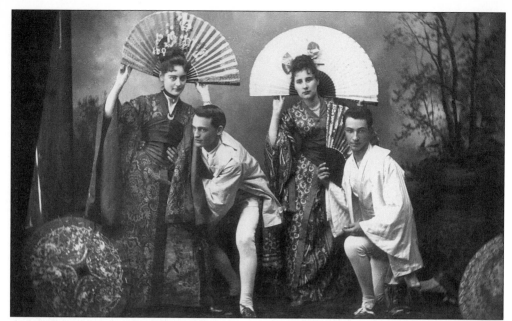

In 1887, when *The Kirmess* was produced, talk already had begun about putting on a production of the popular operetta, *The Mikado*. Some of the participants in that show pose in their exotic Japanese costumes.

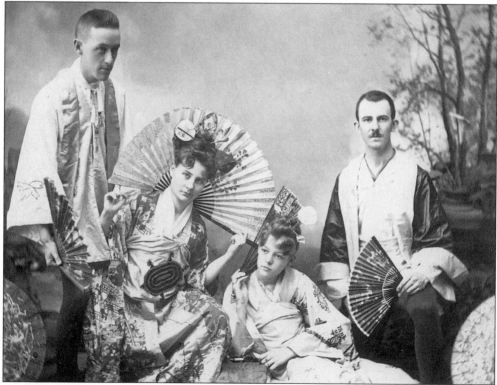

Another group who took part in *The Mikado* show off their costumes and theatrical styles. They are Dick Metcalfe, Juliet Rawle Martin, Camille Carpenter, and Dee Aldrich.

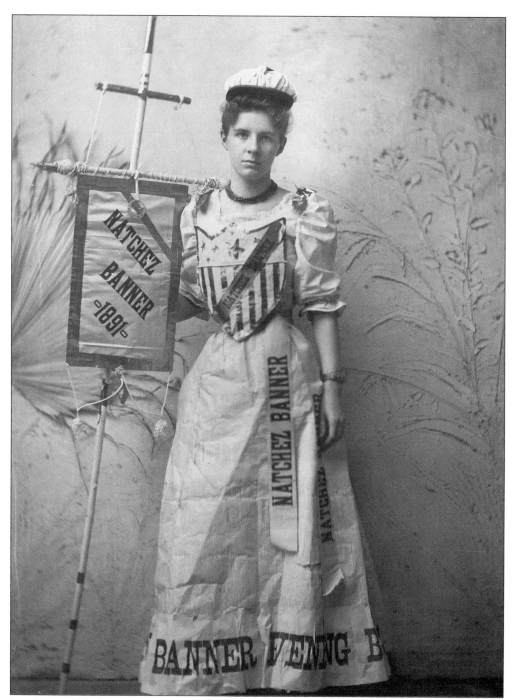

In 1891, a delightful performance called *Business Men's Jubilee* was held at the Pearl Street Institute Hall, often referred to as the Opera House in the 1890s. "Every trade and calling, mercantile, professional, etc., will be represented on stage by a handsome young lady," the newspaper reports. Gertrude Montgomery poses in her newspaper dress to represent *The Natchez Banner*.

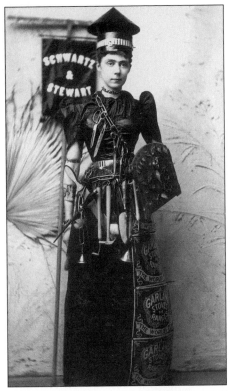

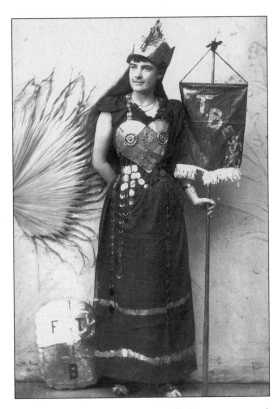

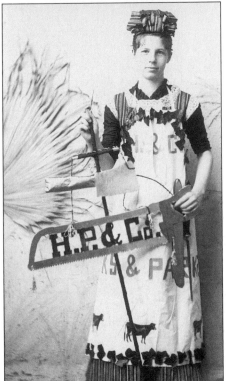

Miss Young, above left, wears all the trappings of a hardware store on her Jubilee outfit—scissors, hammers, spades, knives, and repetitive banners advertising Garland stoves and ranges. Miss Smith, above right, shines in a memorable heart-shaped breastplate in her representation of F.T. Bessac's shop. Eyeglasses were a specialty, and lenses form a drape for the skirt of her costume. Inez Montgomery, left, holds a meat cleaver and some other unidentifiable representation of Hicks Parker & Company, where beef obviously was a major product. About 70 young ladies took part in the show, each one calling out the name of the business she represented as she was introduced.

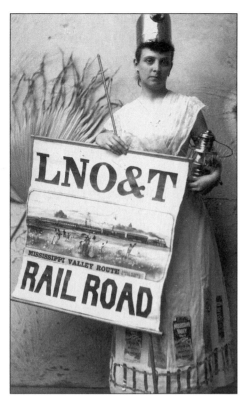

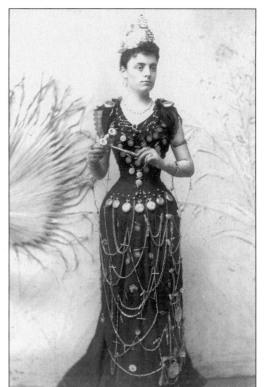

Railroad tracks adorn the hem of Miss Popkin's skirt, above left, and her large sign leaves no doubt which business she represents. The name of the jeweler, above right, is not evident anywhere in the photograph, but bar pins, many watches and chains, and a lovely pair of opera glasses create a fine costume for one of the Natchez businesses. Miss Stanton, right, drips with teacups and crystals. Tiny cupids sit on her shoulders. And even her headdress holds small china cups and saucers and figurines. Sponsored by M&G Company, she was one of many of the young ladies who took advantage of Henry Norman's offer as advertised in the local newspaper to "make the photos free of charge."

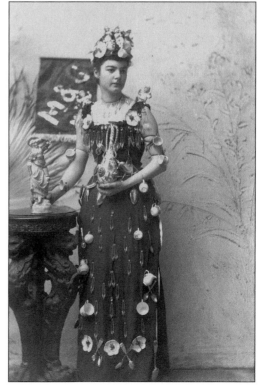

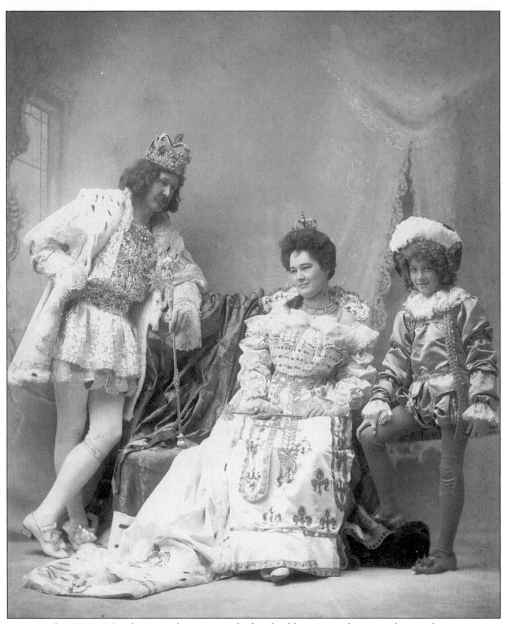

Later in the 1890s, Natchez socialites revived what had been a tradition earlier in the century—the celebration of Mardi Gras. The revival continued for about 15 years and then the gala celebrations were discontinued in Natchez until the 1980s. In 1900, Lemuel Conner, king, Agnes Carpenter, queen, and Audley Conner, page, pose for a Mardi Gras portrait.

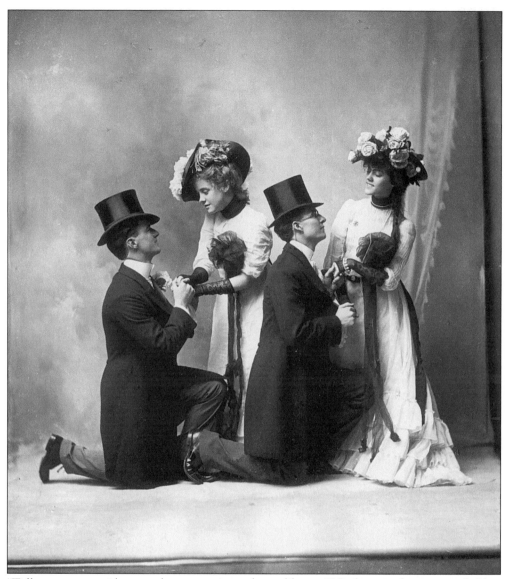

"Tell me, pretty maiden, are there any more at home like you?" Perhaps in the moment for that famous line in *Flora Dora*, the attractive couples pose to re-enact a scene from the popular musical performed in Natchez about 1904.

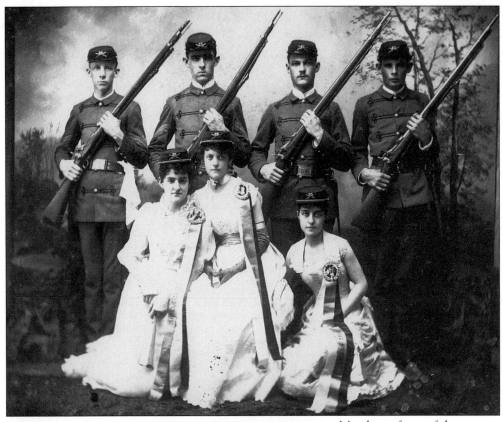

Members of one of the Natchez Rifles, above, one of the town's volunteer militia groups, pose with some of their favorite belles in an 1890s portrait. Four other members of the Natchez Rifles, left, choose weapons over beauties for their portrait. They are Charles Patterson and James Cole, in front; and Brinton Davis and William Percy Stewart, in back.

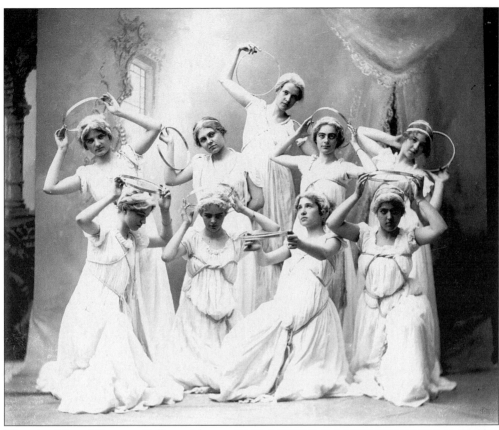

The nine Muses? Stanton College girls, nine in all, above, perhaps represent the Muses as they pose in costumes worn in some excellent entertainment about 1900. The Muses, after all, were keepers of poetry, arts, and sciences, all of which these costumed beauties studied at the school located at Stanton Hall from 1894-1901, and then at Choctaw. The dancers include Edna Green, Mary Louisa Griffen, Katherine Balfour, Annie Green, Marie Balfour, and Miriam Tillman. The bicyclist, right, remains unidentified, but his style is undeniable.

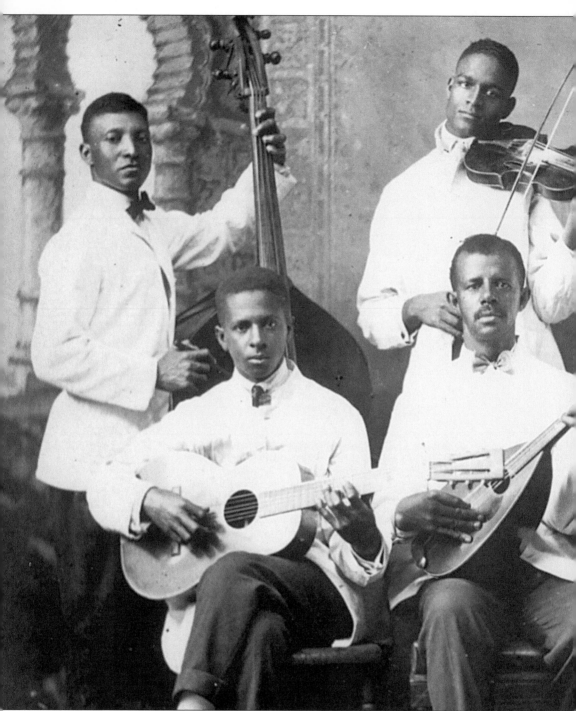

The famous Bud Scott, second from right, standing, poses with his orchestra in the early 1900s. Seated are Leo Roderick, Fox Russell, Ed Shaw, and Jim Ferguson; standing are Ronnie Skillens, Perk Rowan, Scott, and Walter King. The orchestra performed on Mississippi River steamboats, at many balls and other gala occasions and by special invitation in cities around the area, including New Orleans. The musicians took part in early Natchez Pilgrimage events in the

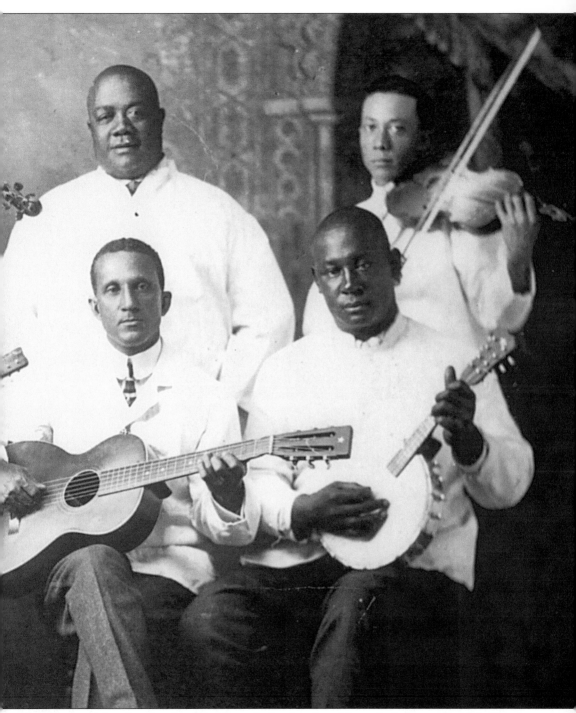

1930s, also. A lovely tale told of Bud Scott is that he played from the balcony of a Main Street store on summer evenings and kept watch for the town's police chief, Mike Ryan. As soon as Ryan came into view, the band would begin playing "My Wild Irish Rose," in honor of Ryan's cherished Irish heritage.

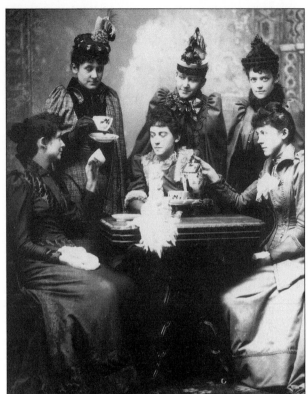

Props galore accompanied customers to the photography studio. Six friends, left, brought their own tea set for a portrait at Norman's Studio in about 1890. They are, seated, Zelia Wade, Zelia Huntington and Florence Lathrop; and, standing, Rose Postlethwaite, Alice Rose Jenkins and Bessie Rose Patterson. Maude Lowenburg, below left, brought along a smashing hat to wear with her ball gown.

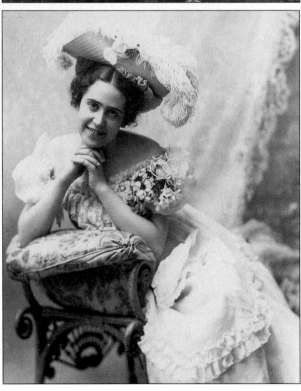

Bessie O'Cavanaugh, standing, and her sister, Minna, pose, at right, with a copy of Haydn's "Third Mass." The top of the cover indicates that the piece comes complete with Latin words and accompaniment for organ or piano. The two sisters, who had four other sisters and lived within a block of the cathedral, were outstanding musicians. They played the organ and sang at St. Mary's Cathedral and gave private music lessons as well. Two nurses, below right, wear the uniforms typical of their profession in the 1890s.

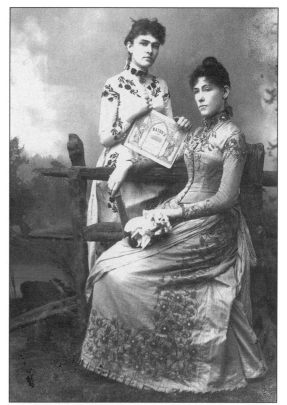

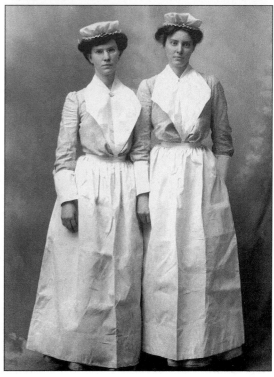

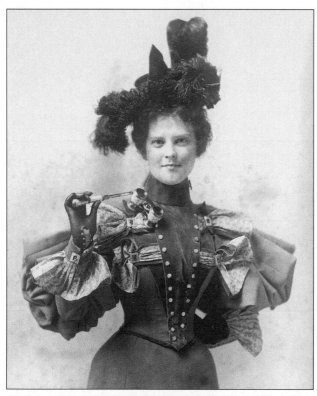

Miss Partridge, left, brought along elegant opera glasses to hold daintily as she stood in an extravagantly trimmed evening outfit. Viewing portraits such as Miss Partridge's and many others so many years later leads to curiosity about the occasions, motives, decisions, and personalities of all the myriad of people who visited Norman's Studio. Miss Partridge, for example, had two portraits made on this occasion—one with the opera glasses and one without. Both are lovely. The McMurtry sisters, below left, Rebecca and Fannie, wear beautiful lace mantillas to complement their fashionable plaid dresses. Fannie, an adopted daughter of the Andrew Wilson family, grew up at the mansion Rosalie and became an accomplished artist.

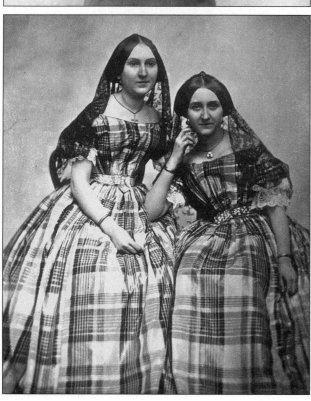

Louis Fitzpatrick, right, looking jaunty and proud, wears the uniform signifying his participation in the Spanish-American War. Firemen Allanburg and Morris, below right, represent the two volunteer companies who shared a firehouse in the late 19th century. Both the Protection No. 3 and Eagle Hook & Ladder No. 2 had headquarters in the firehouse on Commerce Street between Main and State. For many years, volunteers manned firehouses in Natchez and were the sole protectors against destructive fires. The groups acted as social as well as civic organizations, taking part in many lively functions during the late 19th century. Many of the most popular picnics and parades took place under the auspices of the volunteer firemen.

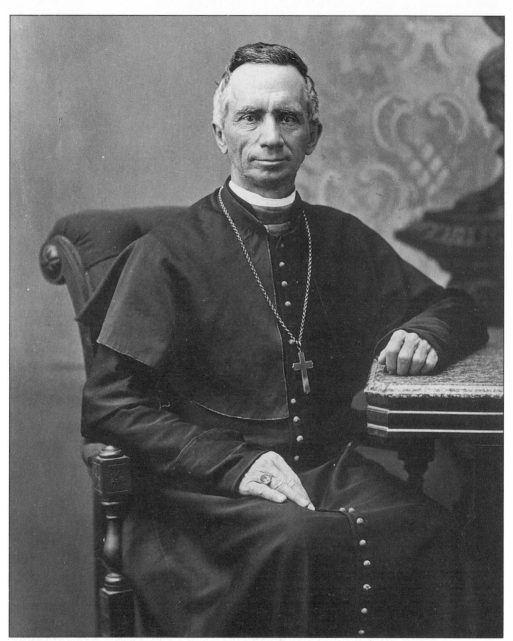

Many prominent people climbed the stairs to have portraits made at Norman's Studio in the late 19th century. One was Bishop William Henry Elder, who poses in about 1878. Elder became renowned during the Civil War for standing up to a Union general following occupation of the city in 1863. The general, hearing that Elder had said a prayer each week at St. Mary's Cathedral for the Confederate president but no longer did so because his congregation included many Union soldiers, ordered Elder to say a prayer each week for Abraham Lincoln. Elder admired Lincoln but he refused to obey the order—not for political reasons but because he recognized the state-church conflict. Elder was exiled, across the Mississippi River to Vidalia, Louisiana. Washington officials took sides with Elder, however, and the bishop's exile was short lived.

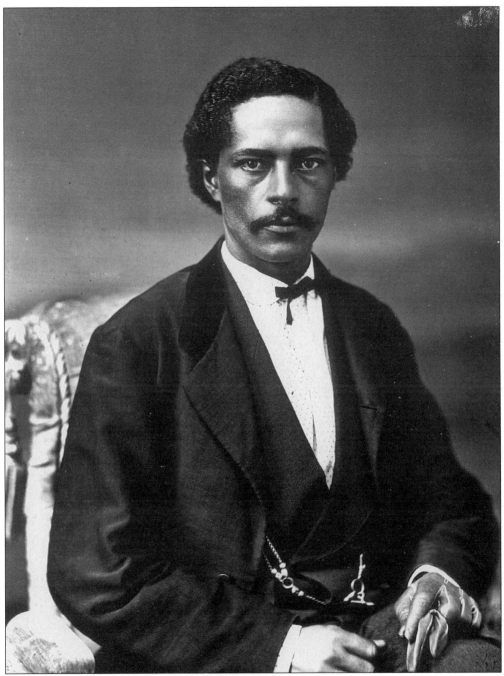

John R. Lynch poses in the 1870s, elegantly dressed from his tailored suit to his leather gloves. One of Natchez's most prominent black leaders, Lynch was born a slave at Taconey Plantation near Vidalia, Louisiana, and brought as a young man to the mansion Dunleith to be a house servant. Self-taught, he entered politics in the post-Civil War years and from local successes went on to become Speaker of the House in the state Legislature and then a U.S. Representative from Mississippi. He owned plantations and studied law, eventually gaining admission to the bar in Washington, D.C., Mississippi, and Illinois.

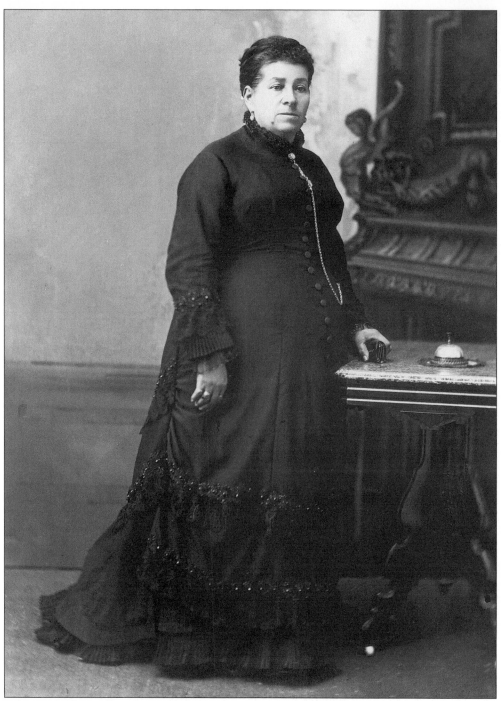

Rebecca "Ricka" Tillman was among the city's most charitable women in the 19th century. A member of Temple B'Nai Israel, she was revered by people of all faiths, as evidenced by notes made in a diary by First Presbyterian Pastor Emeritus Joseph B. Stratton in 1899 after attending her funeral: "The attendance was immense and her loss seemed to be deplored as a public calamity." Dr. Stratton, in fact, delivered a eulogy at the funeral.

Joseph B. Stratton, right, began his ministry at First Presbyterian Church in 1843 and continued to serve the church for 50 years. For the last 10 years of his life, 1893-1903, he was pastor emeritus. The beloved minister made an immense historical contribution during his lifetime by keeping a detailed diary of life in his church and elsewhere in the city. The Rev. Joseph Kuehnle, below left, began his service at Trinity Episcopal Church in 1914 on the eve of World War I. He remained through that war and through World War II, serving the parish until his death in 1946. Bishop William Mercer Green, below right, poses in his later years. An eminent clergyman, he was Episcopal Bishop of Mississippi from 1850 to 1887 and rector of Trinity Episcopal Church in Natchez from 1850 to 1852.

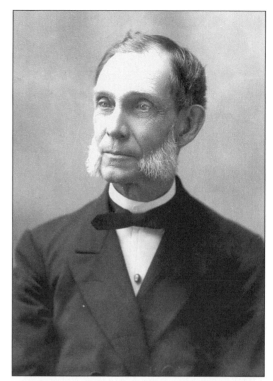

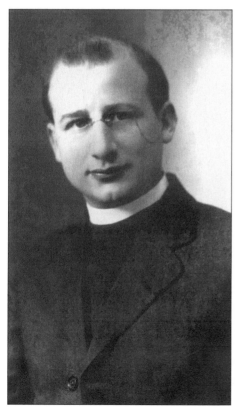

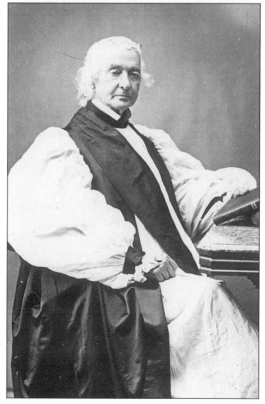

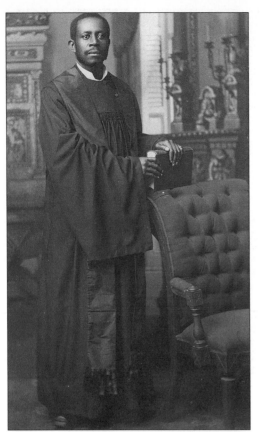

The Rev. Thomas, left, poses in his robe and collar in the 1880s. Perhaps serving for a time at the Zion Chapel African Methodist Episcopal Church, the minister would have been among the prominent black leaders in the community at the time. Natchez Mayor William Benbrook, below left, poses with a ledger in an 1890s portrait. Benbrook was elected in 1889 and continued to be a popular mayor for many years, serving until 1922. Maj. Thomas Grafton, below right, editor at *The Natchez Democrat* in the 1890s, has a few copies of the newspaper along with him for a portrait at Norman's Studio. Grafton spearheaded several efforts to promote Natchez as a place to visit in the late 19th and early 20th centuries. The publications featured photographs of some of Natchez's pre-Civil War mansions. His granddaughter, Katherine Grafton Miller, followed in his footsteps as one of the principal founders of the Natchez Pilgrimage in 1932.

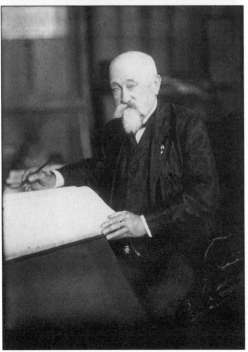

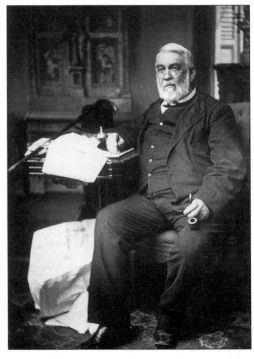

Rufus Learned, right, sits for a portrait in the 1880s. Learned was well known in civic, social, and business circles. Owner of the prosperous Learned's Lumber Mill, he invested also in enterprises such as the cotton mills, railroads and other real estate. Joseph N. Carpenter, below, and his wife, Zipporah Carpenter, were among the most philanthropic of Natchez couples. In the early 1900s, the family donated many thousands of dollars for the construction of two large brick public schools which still stand today— Carpenter No. 1 and Carpenter No. 2. The Carpenters lived at Dunleith and had businesses in Natchez as well as in New York.

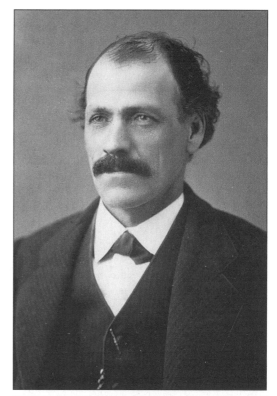

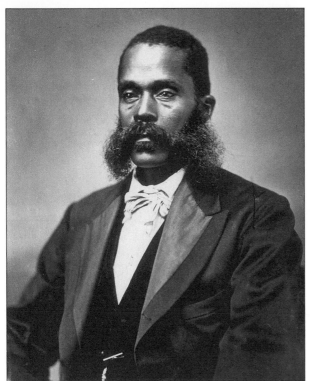

Alex Mazique, left, wears his own version of muttonchop whiskers in a portrait made in the 1870s. The Maziques were slaves before the Civil War. Afterwards, they were hard workers who steadily amassed property and ran successful plantations. The Maziques became one of the area's most prosperous families in the post-war years. They owned a fine townhouse on Pine Street in addition to the plantations. Identified as a "daughter of Alex Mazique," below left, this young lady poses in a stylish outfit set off by the small bustle popular for the younger set in the early 1880s.

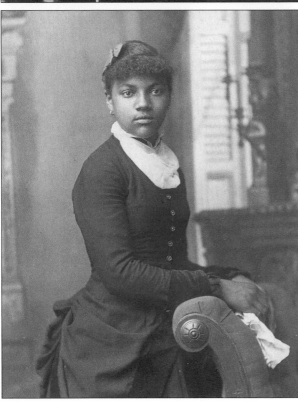

At times, Henry Norman created portraits which rivaled great works of art. Mr. MacDougal, above, worked as a painter for the Dixon firm on Main Street. He sat for a portrait which today demonstrates beautifully Norman's ability as a portraitist. One of the most admired portraits made by Norman during his long career is of the unidentified man with the pipe, below. Similar in tone to the MacDougal portrait, this one, made at about the same time around 1900, resembles a Rembrandt painting.

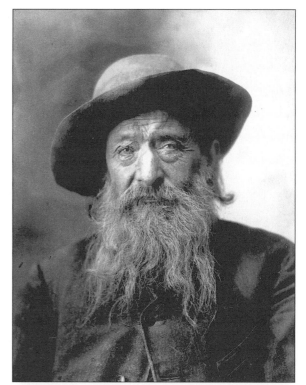

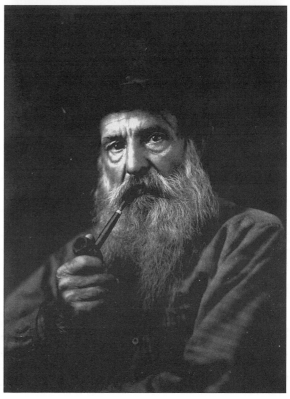

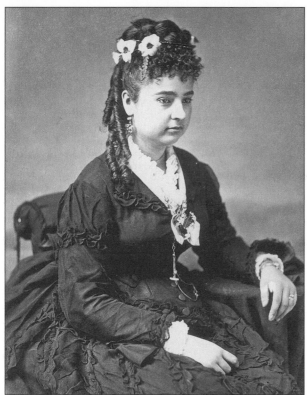

An unidentified lady, left, wears a dress which is simple compared to some worn in the late 1870s period, with only small plain ruffles to enhance the lines. However, a smashing hairdo makes up for any other simplicity in the outfit. Ringlets over her shoulder and tinier ringlets at her forehead are crowned with flowers and braids. The Britton sisters, below, are Ruth, seated, and Eliza, standing and wearing her hat. They beautifully epitomize the stylish set in Natchez in the 1880s in their dark silk dresses adorned with ribbon, lace, and flowers.

Many husbands and wives came together for portraits at the photography studio. Some had separate photographs made. Some sat together. In many bridal photographs, the husband sat and the bride stood. An unidentified couple, right, poses in the 1880s A dutiful wife sitting on a stool by her husband's chair, the wife also properly wears her husband's image over her lace collar. Other family groups, sometimes entire families, came for portraits, too. The Lehmann twins, below, came to the studio. They are Jonas and Karl—or is it Karl and Jonas? The twins spent their careers in separate cities, one in Natchez and the other in New Orleans. Descendants today admit they have no clue as to which one is which in the grand portrait made by Henry Norman.

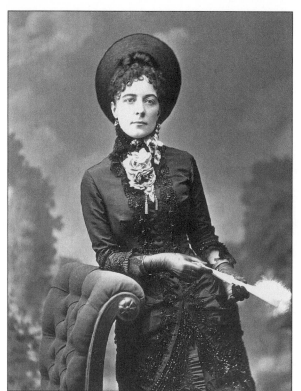

Annie Sessions, left, wears a silk dress beautifully trimmed with jet beads. The fully adorned neckline includes not only two different kinds of fabric flowers but also a pendant and a cameo. A world traveler, she never married and was known as a determined, highly-spirited woman in her day. Annie Toler, below, wears a fashionable two-piece dress in her 1888 portrait. Beads, buttons and pleats accent the outfit, complemented by her stunning hat and leather gloves.

Bustles reached a high point in the late 1880s, and this one worn by Ann Elizabeth Wilson Thompson is an excellent example. A beautiful braid-trimmed cape to match the dress hangs nearby in the picture as does what appears to be a fine feathered hat.

A less-than-form-fitting fashion took hold in the early 1900s. Treeby Victoria Poole, left, wears it charmingly. A popular dancing teacher for many decades in Natchez, she created many ballets for the pageants held during the early years of the Natchez Pilgrimage. Caroline Benoist, below left, poses at the piano a few years before the country was thrown into World War I. Miss Benoist lived with her family in a large, stylish South Union Street home and grew up with a twin brother, Percy. The family owned the prominent Benoist Brothers store on Main Street. Margaret Shields, below right, poses in 1918 in the parlor at Lansdowne, where she grew up. Orphaned at an early age, she was reared by her aunt, Agnes Shields Marshall.

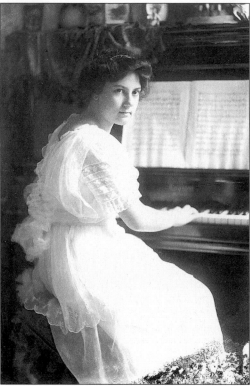

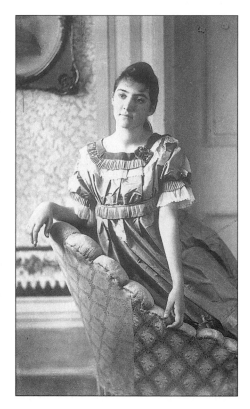

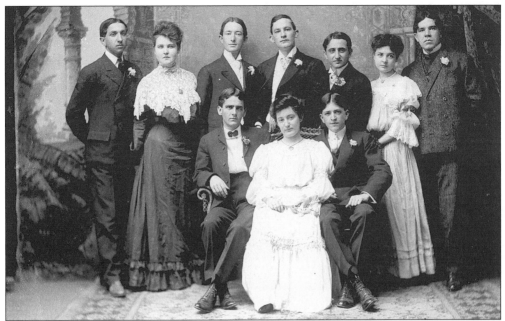

Margaret Noonan sits at center in the front of a grand group photograph. No one is certain of the occasion, but a couple of Margaret's relatives join her for the picture—Ella, second from right, and Joseph, immediately behind Margaret. However, Francis Parnell Burns and Honora Grady Burns are the two standing at the far right. A Natchez moment, the photograph will remain charming despite the mystery, or maybe more so because of it.

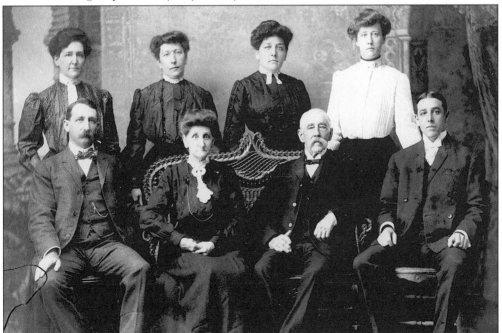

The Hendersons pose about 1900. They are, in front, Waldo P. Henderson, Ellen Newman Henderson, the Rev. John W. Henderson, and Thomas Newman Henderson; and, in back, Nellie Henderson, Florence Henderson, Corrine Henderson, and Anna Henderson.

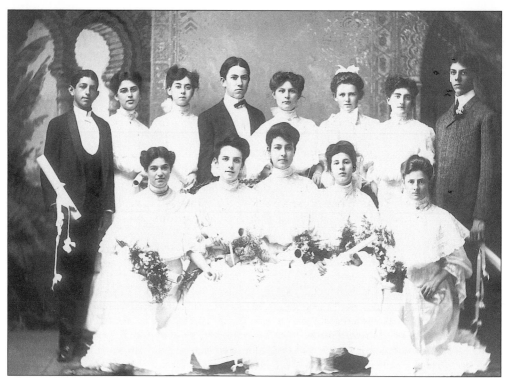

Teachers frequently had students line up for class photographs. In 1904, graduates of the Natchez Institute gathered for a commemorative portrait, the boys holding diplomas and the girls, traditional bouquets.

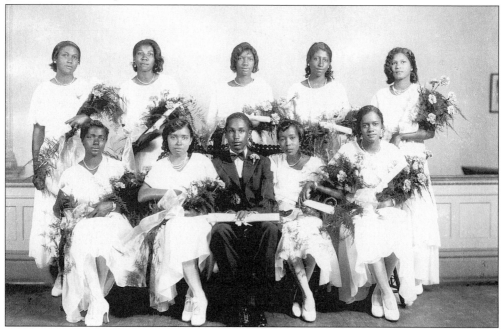

At Earl Norman's Main Street studio, Natchez College graduates came in about 1925, standing with the time-honored props, diplomas for the boys, and bouquets for the girls.

# Four

# ROLLING OUT THE
# RED CARPET

In 1932, a small group of determined, visionary women opened wide the doors of Natchez and invited the world to come. They chose a week in the spring and named it Garden Pilgrimage Week. They planned tours of historic houses, evening pageants, and festive parades. Other Natchezians many years before 1932 knew that the old city, with its rich history, lavishly-furnished mansions, and charmingly eccentric people, was sure to fascinate outsiders. "There has always been a peculiar attraction about the old community," Judge Richard F. Reed of Natchez said of his hometown in a 1915 article. "It has had a lure for many who have come to visit within its hospitable precincts." And local newspaper editor Thomas Grafton in 1887 described Natchez as "the garden of the South, the favorite land of the emigrant hunting a home." But it was the garden club members, poor but plucky, who executed their remarkable idea. Today known as Spring Pilgrimage and five weeks instead of one, the event attracts many thousands of visitors each spring and has been the impetus and inspiration for year-round tourism activities. The early years of Pilgrimage provided an excellent opportunity for photographer Earl Norman. His photographic account of Pilgrimage in the 1930s includes many of his triumphs as a portraitist as well as an architectural photographer.

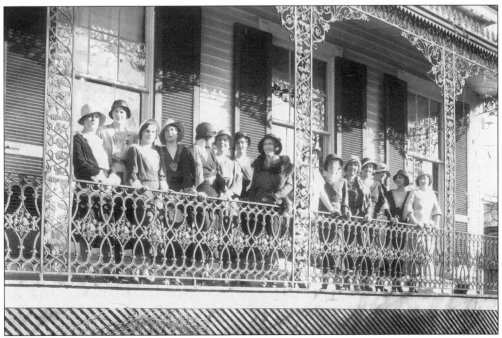

Gathered on a small porch at Green Leaves, members of the Natchez Garden Club pose in a classic photograph made during a Pilgrimage planning meeting in 1932.

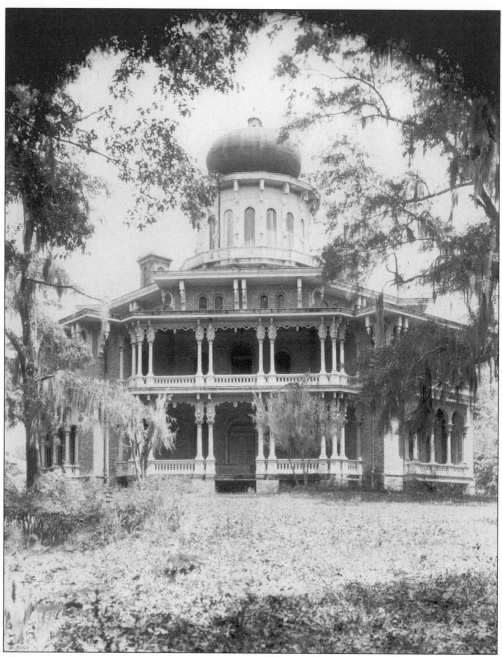

The word *garden* in the name Garden Pilgrimage Week did not mean that visitors would see real gardens everywhere. And at most of the houses, the gardens were the least of a visitor's attraction. The house Longwood, for example, left visitors awestruck even though grounds surrounding the house were untidy as shown in Earl Norman's photograph. Today, the house continues to stun visitors; however, the house—and grounds—are immaculately kept by the owners, the Pilgrimage Garden Club.

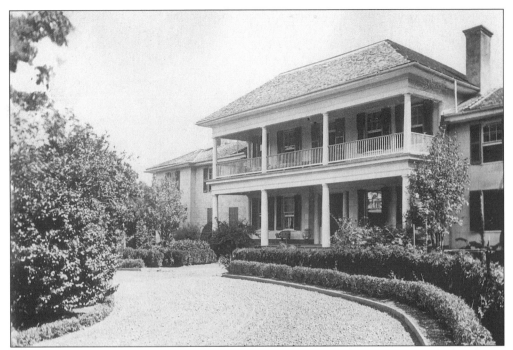

Magnolia Vale was one house on the first Pilgrimage tour which could boast of real gardens. In fact, Brown's Gardens—so named for Andrew Brown, the man who built the house and created the gardens—had been an attraction for visitors back in the heyday of steamboat traveling. Gardens or not, visitors had much to see at the house below the bluff built nearly 100 years earlier.

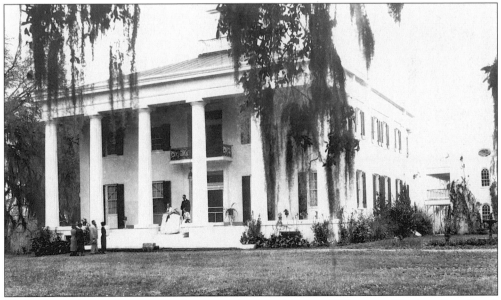

With a hoop-skirt and a curtsey, a hostess welcomes visitors to D'Evereux. The excellent Greek Revival-style house was built in Natchez in the 1830s, celebrating its 100th anniversary during the early Pilgrimage years. The mansion continues to open its doors to visitors as another century dawns.

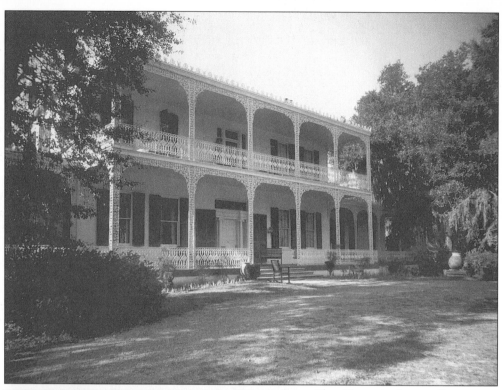

Elms Court, its front galleries framed with lacy iron, was the setting for a gala in the early Pilgrimage years known as the Ball of a Thousand Candles. A seated supper was served to the light of "a thousand candles." Men, many of them skeptics when their wives suggested the Pilgrimage idea, took part as hosts during Pilgrimage Week. At his home Elms Court, David McKittrick, left, was a popular host. The daily newspaper wrote in April 1933, "Mr. McKittrick, who is noted for his delightful hospitality, [makes] visitors want to make Natchez their home forever."

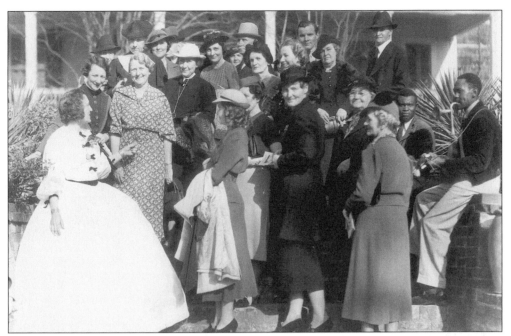

Katherine Miller, in costume, greets visitors at her home, Hope Farm. Musicians sit on the steps to play, adding to the festive occasion. Mrs. Miller was a major player in founding the Pilgrimage. She traveled around the country to publicize the annual event. And her organizational abilities and enthusiasm helped to encourage the volunteerism vital to the success of the Pilgrimage.

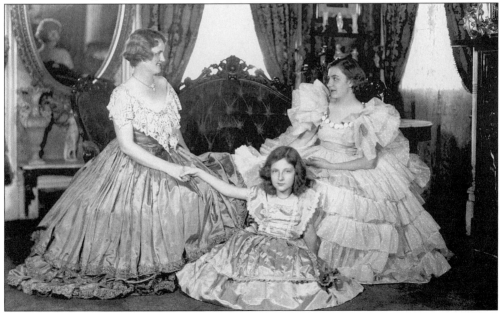

Ruth Audley Beltzhoover, beautiful hostess and successful businesswoman, poses with daughters Ruth Audley, right, and Virginia, in the parlor of their family home, Green Leaves. Daughter Virginia Beltzhoover Morrison continues to open the grand old house to visitors each spring.

Mary Britton Conner, for so many decades a leader in Natchez's social and civic activities, also took part in early Pilgrimage activities. Here she poses with daughter Eliza Conner Martin, who assisted her mother in welcoming guests to their family home, Clovernook. Eliza is wearing an original 19th-century dress, as many hostesses did in the early years of Pilgrimage.

Margaret Marshall stands on the steps of her home, Lansdowne, with daughter, Devereux, and sons, Neville and George. Lansdowne remains in the Marshall family, where Devereux Marshall Slatter continues to live, and opens the house to visitors year round. The elegant parlor at Lansdowne has retained much of its original appearance for the nearly 150 years since it was furnished. The same family has occupied the house through the seven generations of its existence.

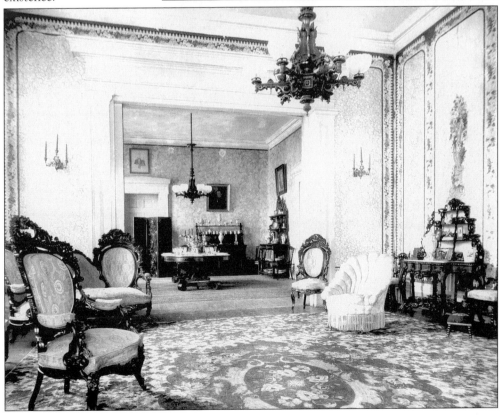

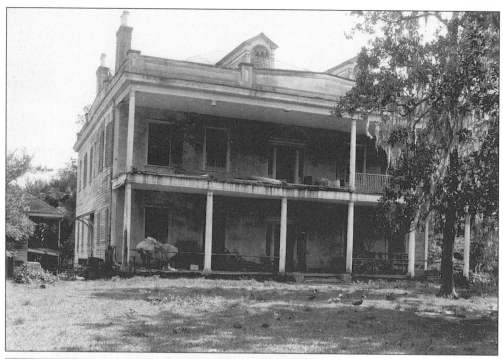

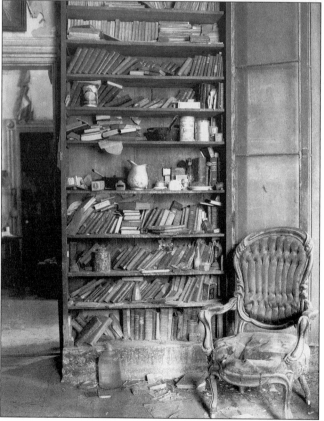

One attraction during the early Pilgrimage years was Glenwood, known then by many as Goat Castle because the eccentric owners allowed animals to wander in and out of the house. Once a beautiful residence, Glenwood deteriorated to a dreadful state of disrepair. The library of fine old leather-bound books, left, fell victim to goats and other pests. And it didn't help that the residents, Dick Dana and his companion, Octavia Dockery, stashed oatmeal boxes and dirty plates on the shelves with the books. Visitors flocked to see the run-down house and meet the odd residents, whose notoriety rose to greater heights in a highly publicized murder of a neighbor.

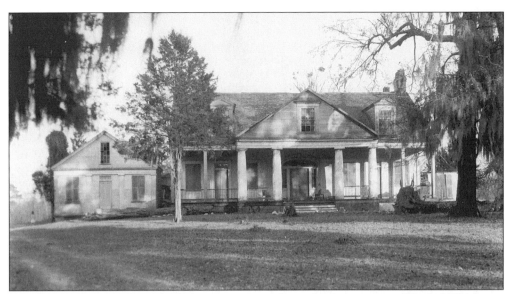

Another exotic extra awaited Pilgrimage visitors a few miles from town at Windy Hill Manor, where time seemed to have stood still. An aura of yesteryear enveloped visitors as they traveled the shadowy, rutted road leading to the house.

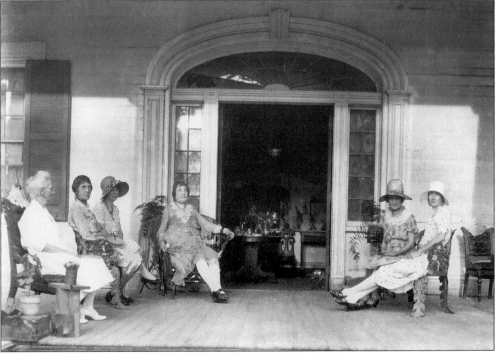

Visitors paid an extra 25 cents to tour Windy Hill Manor, where the Stanton sisters showed them around the house and, best of all, told stories of romance and intrigue associated with the old estate where they had lived all their lives. Posing on the porch of Windy Hill Manor with cousins from Mount Airy next door, Elizabeth and Beatrice Stanton flank the front door; sister Maude is second from left. When the last sister died, the grand house sat empty for many years and eventually was demolished.

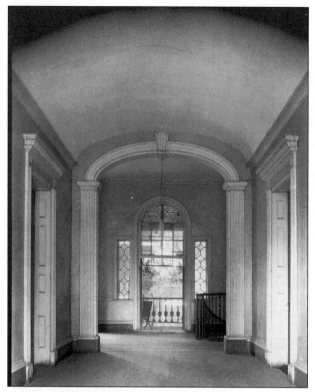

Some of the ancient mansions were sparsely furnished during the early Pilgrimage tours. In the case of the upstairs hall at Auburn, however, furniture was not required for visitors to appreciate the architectural grandeur. As the first house of its style to be built in Natchez, Auburn, constructed in 1812, stood a testament to wealth and taste in the town's early 19th-century years. At Melrose, below, on the other hand, lavish furnishings chosen when the house was new in the 1840s completed the setting, offering visitors a glimpse into the lifestyle of a wealthy Southern family during that era, when cotton cultivation dominated the economy.

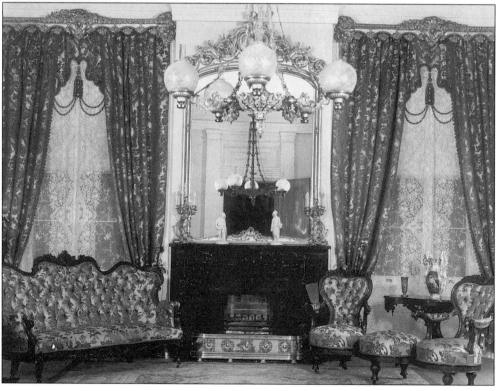

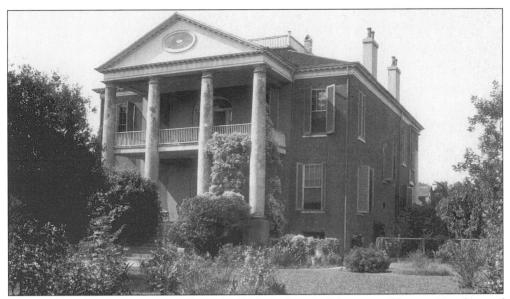

Beautiful Rosalie shows its age in the early 1930s, before the Mississippi Chapter, Daughters of the American Revolution, purchased the house from the Rumble sisters who lived alone there. The D.A.R. gave the brick mansion an excellent facelift and began to restore the gardens and the interior of the house in 1938. Visitors in the early years of Pilgrimage overlooked the seedy garden and peeling paint, however. The house, built near the bluff overlooking the Mississippi River, retained its original style and beauty; and lovely stories of Peter and Eliza Little, the first owners, enchanted visitors then as today.

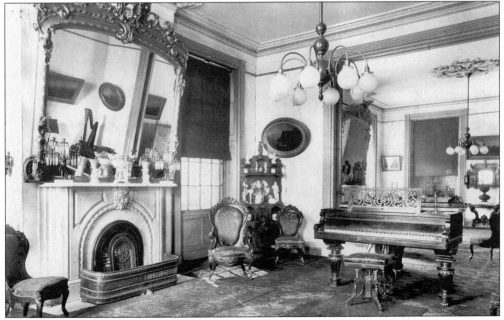

Inside Rosalie, many of the fashionable furnishings purchased for the house by the Andrew Wilson family in the 1850s remained in place when doors opened to Pilgrimage visitors in the 1930s. The D.A.R. continues to own and maintain Rosalie today and to open it to the public year round.

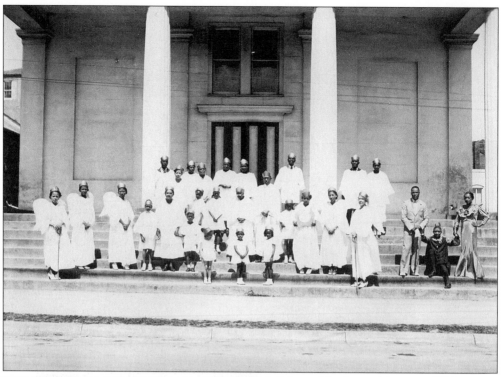

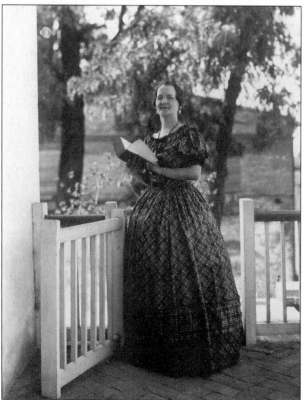

Members of the cast of "Heaven Bound" pose on the steps of Zion Chapel African Methodist Episcopal Church, at the corner of Pine and Jefferson Streets, in the early 1930s. The musical drama, featuring choir and solo pieces and roles for children, was a popular form of entertainment during the early Pilgrimages. Edith Wyatt Moore, left, wrote stories about Pilgrimage and, perhaps more important, about the history of Natchez and of the old houses and the people who lived in them. Her articles appeared not only locally, in annual special editions of the newspaper made available to visitors, but also nationwide in major newspapers and magazines.

Louise Metcalfe, right, stands near the front door of her home, Ravenna, welcoming guests who have come to tour in the 1930s. A narrow lane from South Union Street took visitors into a lush garden setting surrounding the house, which remains today an often-toured house and one of the most picturesque of the great Natchez mansions. Myrtle Clark Eyrich, below right, poses with daughter Marie Louise and one of her two sons, George, at their home Stanton Hall. A few years later, the Pilgrimage Garden Club purchased Stanton Hall from the family. The club continues to own the house and to open it daily to the public.

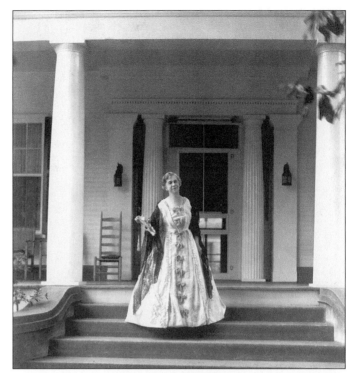

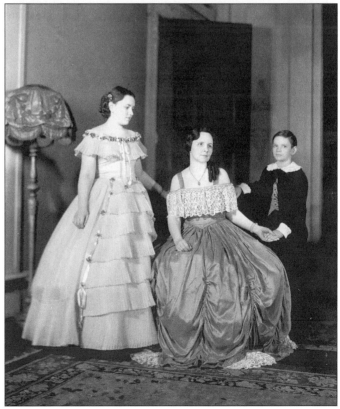

Many garden club members who founded the first Pilgrimage also lived in historic homes which were opened to visitors during those first years in the 1930s. Rebecca Benoist, above left, was president of the club in 1932. During the 1930s, she welcomed tourists to Propinquity, a historic country home owned by the family for many generations. Alma Kellogg, above, also was a leader in the establishment of Pilgrimage tours. Her home, The Elms, was on the 1932 tour, and today her daughter, Alma Kellogg Carpenter, continues to open The Elms for Pilgrimage. Mary Louise Kendall, left, stands at the front door of Monteigne, which her family purchased in 1935 and opened to early Pilgrimage visitors. Now Mrs. Dunbar Shields, she greets Pilgrimage guests each tour season.

Earl Norman's portrait of Clara Chamberlain, right, demonstrates his talents for portraits and provides a beautiful example of many of the young people who took part in the 1930s Pilgrimage events. As the evening pageant became an established event during Pilgrimage weeks, local designers and seamstresses began the Natchez tradition of creating gowns and other costumes appropriate to the occasion and the period dramatized during the pageant's tableaux. Roane Adams, below right, wears a charming costume as she pauses at the front door of Linden, where visitors frequently paused, and still do today, in awe of the beauty of the elaborate Federal-style doorway.

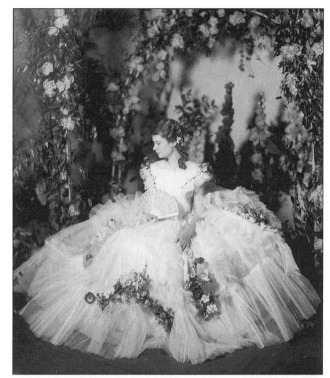

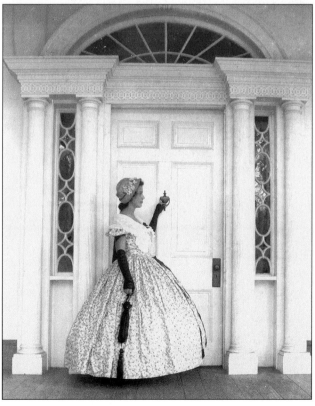

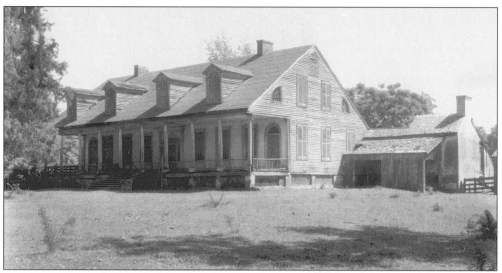

Many of the historic Natchez houses were in need of repair and refurbishing when they opened their gates and front doors to the first tourists. At The Briars, however, the fine old plantation-style house near the river bluff had found new owners in time to show a better face in 1932. Paintless and in poor repair, above, the house was purchased in 1927 by the William Wall family, who painted, restored and replanted the garden, giving The Briars, below, some of its former elegance. Beautifully restored today, the house and its surrounding luxurious gardens are open to Pilgrimage visitors.

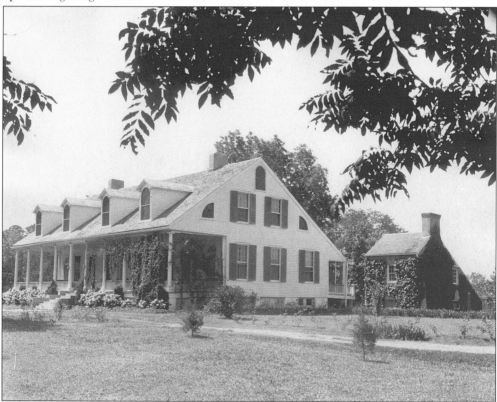

Early Pilgrimage successes inspired restorations such as at the House on Ellicott Hill, purchased in poor repair by the Natchez Garden Club in 1934 and restored to open for tours the next year and continuously since then. The breathtaking restoration is evident in the before and after pictures of the house, built in about 1800 on a high hill where in 1797 Andrew Ellicott raised the first American Flag to fly over Natchez.

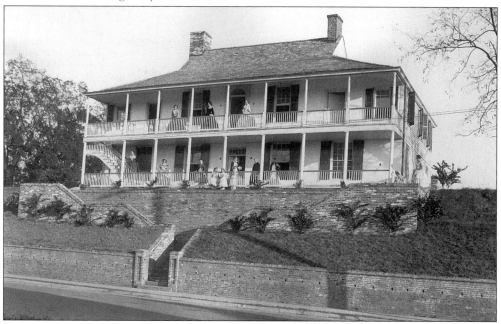

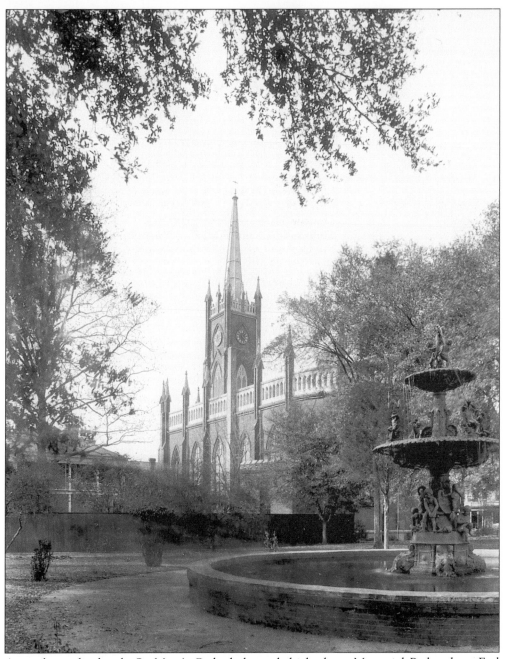

An enduring landmark, St. Mary's Cathedral stands high above Memorial Park, where Earl Norman stood to make one of the most beautiful of his architectural photographs. Today a minor basilica, St. Mary's is one of several historic downtown Natchez churches open daily to visitors.

# Index